FEELS LIKE HOME

REFLECTIONS ON CENTRAL LIBRARY

Edited by
SHERYN MORRIS, CHRISTINA RICE, and JAMES SHERMAN

Foreword by **JOHN F. SZABO**

Photographs from the Collection of

LOS ANGELES
PUBLIC LIBRARY

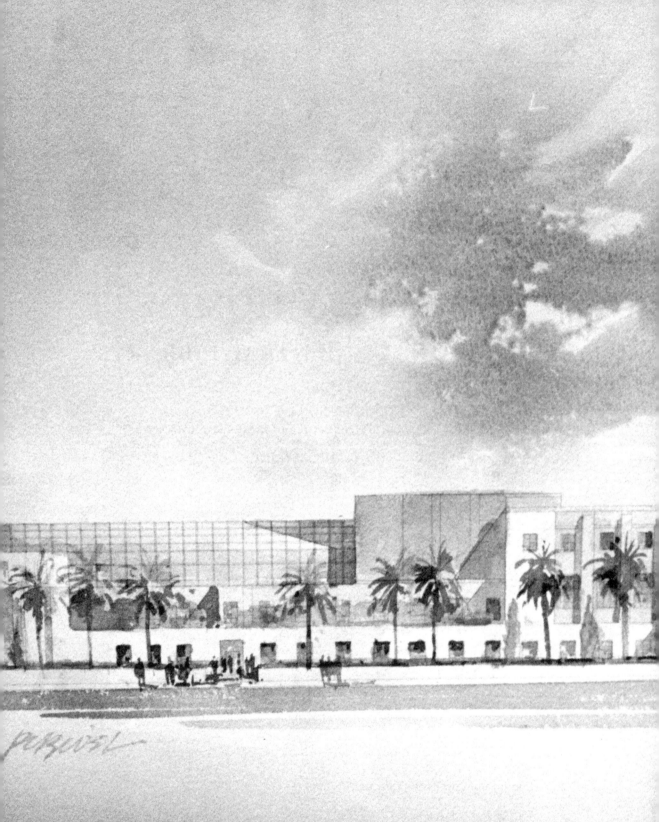

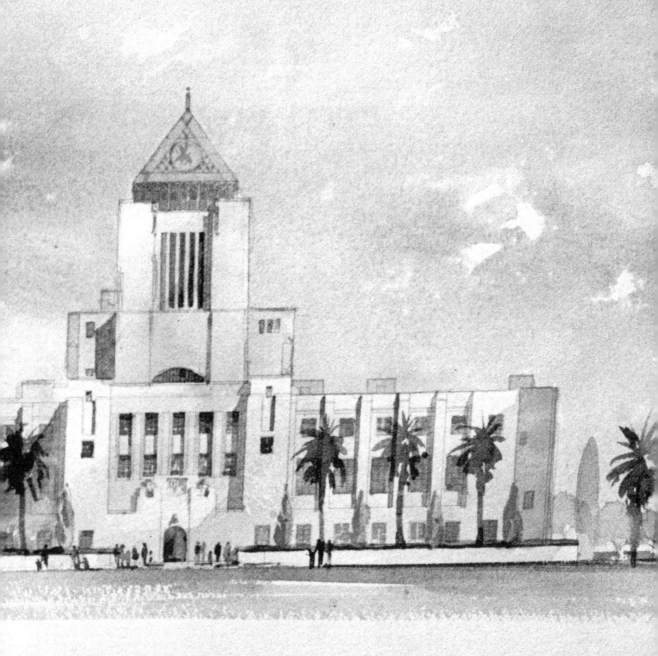

Photo of a watercolor depicting the soon-to-be
renovated and expanded Central Library.
(Mike Mullen, Los Angeles Herald Examiner Collection.)

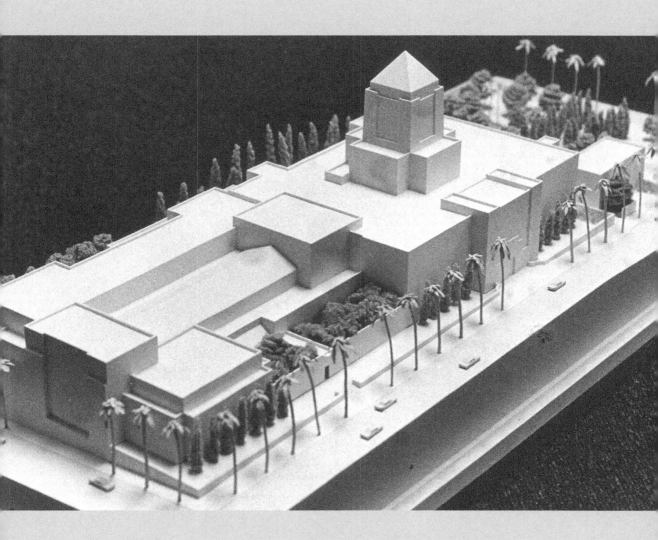

Model of Central Library expansion and renovation on display in 1987.
(Mike Mullen, Los Angeles Herald Examiner Collection)

TABLE OF CONTENTS

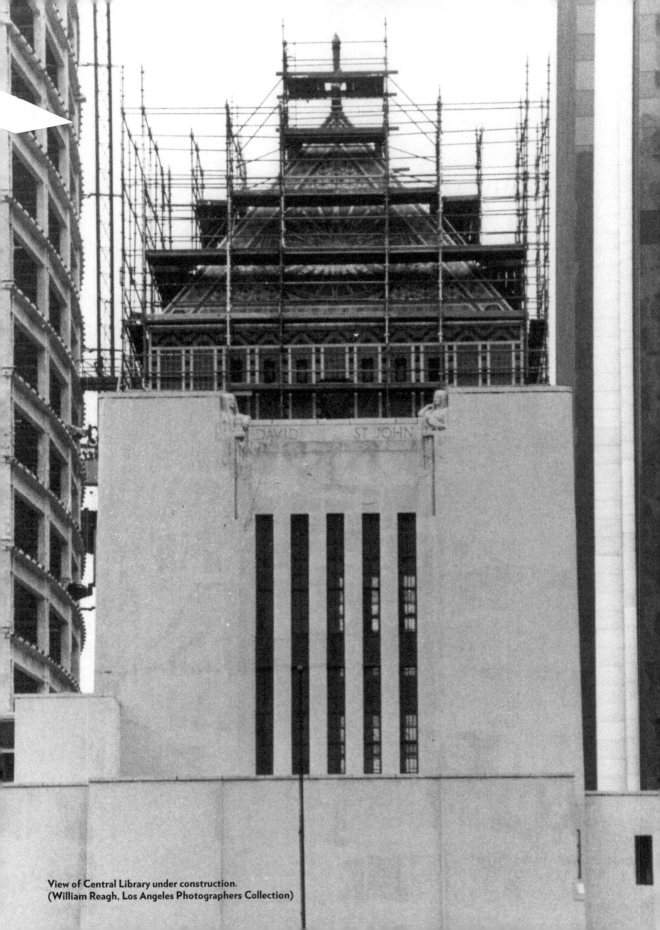

View of Central Library under construction.
(William Reagh, Los Angeles Photographers Collection)

FOREWORD

By JOHN F. SZABO
City Librarian

WHAT A PLEASURE to be celebrating the 25th anniversary of Central Library's reopening! This building is a celebrated landmark in the City of Los Angeles for its art and architecture, but beyond that, there is something very special about Central Library. This place is known to take hold of you—and has inspired countless people in a myriad of ways.

We always say that everyone has a library story, and I think that is especially true about Central Library. I am fortunate to have spent the past six years here, and I am always discovering something new about this building. As is true in many places with rich history, I often wonder how many untold stories are yet to be written and told. As resourceful librarians, we take advantage of every space in this building—using the walls to host exhibits to showcase artists from around the world and treasures from our vast collections. Of course our walls are also lined with books, and we share those stories as patrons browse through and check them out—over and over again.

Libraries are trusted with telling stories, and I am delighted that while Central Library has served Los Angeles for the better part of a century, it continues to grow and change with the times. Especially in the past 25 years since its reopening, I am so proud that the library embraces that constant evolution and remains more relevant today. At Central Library and our 72 branches, dynamic programs and services continue to bring access, opportunity, equity, empowerment and lifelong learning to all Angelenos.

Central Library has been home to numerous new developments during these 25 years, including Teen'Scape, the Digital Commons, the New Americans Center and the Singleton Adult Literacy Center. Libraries have always connected people with what they need, and now our patrons can do that from

Views of Central Library under construction. (William Reagh, Los Angeles Photographers Collection)

anywhere with our accredited online high school curriculum and tremendous collection of online offerings including books, magazines, music, movies and educational courses.

It is my honor and privilege to serve as City Librarian, and as I enter Central Library each day, I am humbled that this is my workplace. One of the things I love most about my job is getting to hear people's library stories. I look forward to the memories we will make as part of this celebration—the next set of stories that will be told about Central Library—and all the ones that will follow.

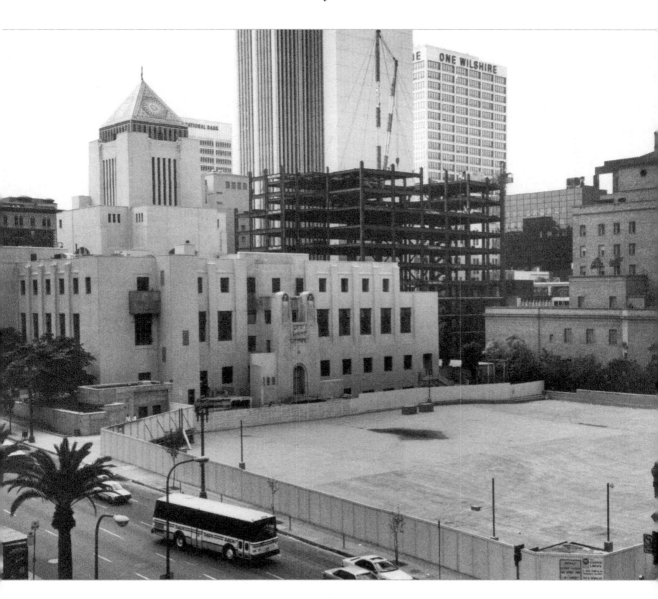

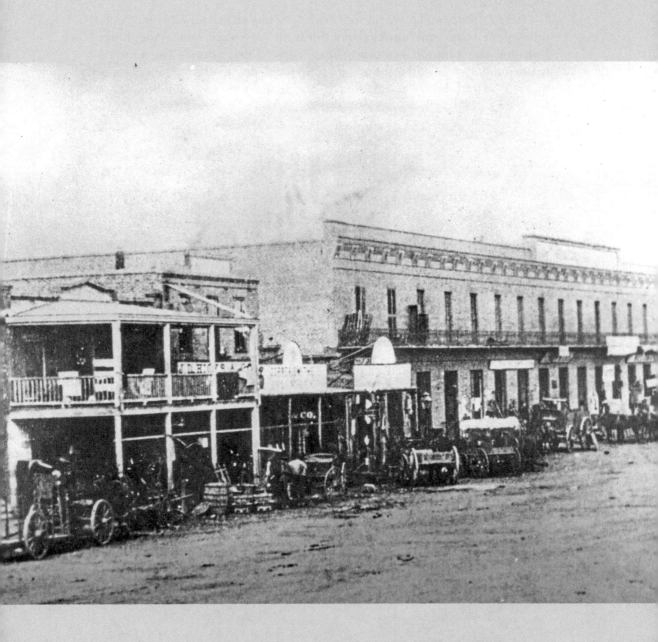

Early view of Abel Stearns' Arcadia block on Los Angeles Street. This was the first brick business building in the city and the location of the first library which opened in 1859 but was short-lived. (Security Pacific National Bank Collection)

A WANDERER AND HOMELESS WAIF

By **GLENNA DUNNING**
Librarian, History & Genealogy Department

PLANNING AND MAINTAINING a library to serve the needs of the reading public is not new to Los Angeles. As early as 1844 a society called Los Amigos del País organized "a social gathering place" where books and magazines could be read. Located in Amigos Hall on North Main Street near the Plaza, the library consisted of a small reading-room with a few tables, chairs, and books and magazines which had been donated by public spirited citizens. Newspapers from "the states" were especially prized, even if they arrived more than six months late. Within a year or two, however, interest in the reading-room diminished and the society, saddled with growing debt, put the property up for sale in a lottery. General Andres Pico, brother of Governor Pio Pico, drew the lucky number and acquired the building, furniture and all reading materials.

In 1856, "The Mechanics Institute" (named after the organization in San Francisco) established a reading-room in a corrugated iron building on the south-east corner of North Spring and Court Streets. It offered a small collection of reading materials but received little financial support and closed its doors in 1858.

It wasn't long after the Institute's reading-room folded that several civic-minded residents began an organized campaign to establish a public library. On April 2, 1859, the Los Angeles *Star* ran the announcement, "All who are disposed to aid in establishing a library and reading-room in the city are requested to meet at Wells, Fargo and Company's Express Office, on Monday evening, April 4, 1859, at 7 o'clock." This meeting proved a success and, on July 11, a group of prominent businessmen, including Felix Bachman, Myer J. Newmark, and William H. Workman organized the Library Association and elected John Temple as president. The association immediately appointed committees to solicit

memberships, gifts and subscriptions, and to secure and furnish library quarters. The Los Angeles *Star* proclaimed, "We are glad to know that the endeavor to establish a library and reading-room in this city is likely to prove successful. An adjourned meeting was held Thursday evening at which the constitution and by-laws were adopted."

The Library Association located suitable quarters in businessman Abel Stearns' Arcadia block on Los Angeles Street and, on September 15, 1859, the new Los Angeles Library opened its doors. On September 24, the *Star* announced that "The Library Association rooms are now open, and are supplied with all the leading periodicals and papers, not only of the state but of the union. Such an institution has long been desired here, and now the want is supplied. We hope the citizens of all classes will rally to its support. The rooms are comfortably fitted up and nowhere can one spend a leisure hour more profitably than by availing himself of the privileges of the Library. The terms of subscription are within reach of all and we hope to see a large list of subscribers." At the time many libraries were not free to the public and charged subscription fees for use of the facilities. Los Angeles was no exception, the Library Association charging five dollars as an initiation fee and monthly dues of one dollar.

Many citizens donated books, magazines, and money to support the Library. Los Angeles Mayor Henry Mellus, who sailed with Richard Henry Dana on the voyage immortalized in *Two Years Before the Mast*, contributed his personal collection of books, and employees of the Overland Mail pledged that newspapers of California, the eastern states, and the "northern frontier" would be collected on various stage routes and delivered to the library as quickly as possible.

The Library flourished for a time, becoming "an attractive resort for the residents, as well as for strangers visiting the city," and it was there that Mayor Mellus welcomed Governor John Downey on his first official visit to Los Angeles. However, in spite of its strong beginning, public support of the Library, for a variety of reasons, began to wane. Perhaps the subscription fees were too expensive, or the delay in receiving eastern newspapers, coupled with the scarcity of new books, proved to be a frustrating annoyance but, for whatever reason, the "project, to the regret of many, had to be abandoned" and the Library Association died out by the start of the Civil War.

For more than a decade, the growing city was without a public library. The desire for books was evident as some local merchants displayed small collections of books and periodicals, or even provided small circulating libraries which they advertised in local newspapers. Nevertheless, several prominent citizens viewed the lack of a public library as a community disgrace and embarrassment. This opinion was mirrored in a Los Angeles *Star* editorial of December 5, 1872, which stated that "the absence of a place where a cultivated person

may go for books of reference or standard library works has been spoken of to our injury abroad."

Possibly in response to that editorial, "another agitation" for a public library led to a meeting on December 7, 1872, in the old Merced Theatre on Main Street where more than two hundred citizens turned out in support of a city library. As a result another Library Association was established, led by Governor John Downey, H.K.W. Bent, and Harris Newmark. They were appointed to a committee which would "canvas the city for subscriptions, donations of books, and to take such other steps as they may deem proper until the next meeting." The subscription form presented to potential supporters stated that "The undersigned, with the view of establishing a public library in the city of Los Angeles, do hereby become members of the Los Angeles Library Association, and agree to pay the sums set opposite our names as donations, entrance fees, or for life membership as specified." The life membership fee was $50 and the annual fee was $5.

At a subsequent meeting on December 14, the committee reported that they had signed up one hundred and fifty members (including nine life members), had secured donations amounting to four hundred dollars, and had received numerous gifts of books. They also found a home for the new library when Governor Downey offered free rent for the first three months if the library would move into a two-room "suite" in his newly constructed Downey block, the monthly rent to be $40.00 after that.

Located on the corner of Temple and Spring Streets, the two-story Downey block was described by the Los Angeles *Daily News* as "the most imposing" brick building in the city, all offices "arranged in suit[e]s, and furnished with gas and water." The Library would share the upper floor with such established neighbors as Ganahl & McDaniel, lawyers; R.M. Widney, lawyer and real estate dealer; the doctors Richardson, Edgar, and Door; Dr. Crawford, dentist; Nichols & Smith, real estate dealers; and George Pridham, saloonkeeper.

In January 1873, the Los Angeles Library opened to the public. It was comprised of two reading-rooms furnished with tables, newspaper racks, and shelves filled with approximately 750 volumes, ranging from literary classics to books on history, travel and fiction. A smaller adjoining room had tables set up for checkers and chess and early records show that it was as popular with the public as the main reading room.

We can get a detailed description of the Library from the recollections of early pioneer William Andrew Spalding. In a meeting of the Southern California Historical Society, he related that

> " ... the Library as I first saw it, was housed in two rooms [in the Downey block]. The front and principal room was probably twenty by thirty feet in floor dimensions, and was fairly lighted

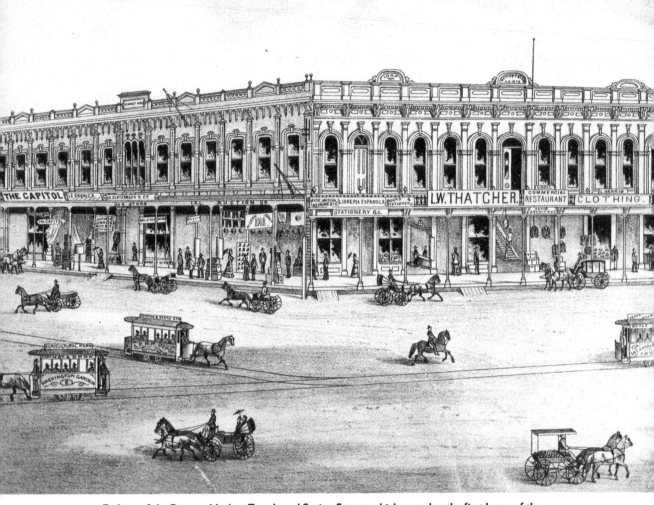

Etching of the Downey block at Temple and Spring Streets which served as the first home of the Los Angeles Public Library from 1872-1889. (Security Pacific National Bank Collection)

by two large windows looking out upon Main Street to the south-east. Back of this, shut off by a half-high partition, was the smaller room—probably twelve by twenty feet-which was used for storage and other general purposes, and a portion set off for chess and checkers. This last equipment consisted of a plain pine table and half a dozen chairs....The main room of the Library at the head of the stairs was lighted by two front windows, and along the two side walls were the book shelves. I make a guess that they contained fifteen hundred or two thousand volumes. These were mainly the books that had been loaned or given by citizens, as the Library was not sufficiently endowed to indulge in the extravagance of new books. In the center of the room were two or three ample tables upon which reposed late copies of the few principal magazines

FEELS LIKE HOME

of that day: *Harper's Monthly, The Galaxy, The Atlantic-Harper's,* and *Frank Leslie's Weekly, Bonner's New York Ledger,* the *Waverly,* and files of the daily and weekly papers of Los Angeles City and County, and of San Francisco. At that time we considered it a noble array. I know that John Littlefield, the Librarian, was very proud of this showing that the Los Angeles Public Library was right up to date."

John Littlefield, former editor of the *Weekly Express,* had been hired as the first city librarian at a salary of $75 per month. He labored ceaselessly to fulfill his responsibilities, spending much of his time tramping around the city seeking financial backing from those who had made a pledge of support. Littlefield was a victim of chronic asthma and, at the first sign of a cough, he would retire to a little room in the rear of the Library where he filled his pipe with dried jimson leaves which he smoked for relief of his symptoms. The smoke may have helped the librarian but did little for the patrons, and it was reported that "the abominable fumes of the burning [leaves] permeated the whole establishment and nearly choked everybody in it. Patrons of high strung temperament generally retired at the first asthmatic signal."

In spite of Littlefield's health problems, he worked hard to improve the Library and its collection. On May 1, 1873, an article in the *Evening Express* recognized his efforts by boasting "We have today the finest Library and the completest [sic] in all its detail and appointments of any in the State south of San Francisco—a delightfully popular resort, which is at once the pride and honor of our city." Indeed, the article announced, the library had "volumes on the shelves ranging from standards in literature to books of history, travel and fiction. On the tables were the important

John Littlefield was the first City Librarian who suffered from chronic asthma and frequently smokes dried jimson leaves in his office, much to the annoyance of the choking patrons. (Los Angeles Public Library Institutional Collection)

American and English monthlies, and at least twenty daily newspapers, and ten weekly papers were provided."

Ladies were becoming active in the use and support of the Library. Although they were not able to obtain their own library cards, "the ladies of Los Angeles had begun to frequent the Library, using the membership cards of the masculine members of the family (for the original membership had been 'men only')." In 1876 a ladies' reading-room was added, "pleasantly furnished and equipped with tables, books and magazines."

Support of the Library became an interest and activity for several members of Los Angeles' high society. In 1877, for example, the Library's "constant growth and increasing demands suggested to Mrs. S.B. Caswell the idea of giving a ball for the benefit of the Library fund. This was the first entertainment given for this purpose. It took place in June 1877, in the old Tumverein Hall ... and proved a decided success, netting $220 for the purchase of books." Other balls and "entertainments" followed, including the Dickens Party, "a social event that will be remembered for the lifetime of the elder generation." Enough funds were raised at an 1880 Dickens Party that $250 of the proceeds was donated to the Library.

In 1879 the City Council passed an ordinance establishing the "Los Angeles Public Library" and making it a department of the city. Los Angeles assumed responsibility for the Library's financial support, and the Library Association surrendered its authority to a new board of regents appointed by the mayor.

A year later the Library suddenly found itself without a librarian. Littlefield had been dismissed for offending readers with his abominable-smelling jimson weed and his successor, Patrick Connolly, was fired for taking more interest in the downstairs saloon than in books. Mayor John Toberman offered the position of city librarian to 18-year-old Mary Emily Foy, a recent graduate of the first class of Los Angeles High School. Foy made a deal with the mayor and city council that, if she were hired as librarian, she would go to Oakland and "study under the best librarians on the coast." This condition was accepted and, in 1880, Foy became the third librarian (and first woman librarian) of the Los Angeles Public Library. She received a salary of $75 a month, out of which she was expected to pay the janitor.

When she started her work she doubtless made note of discrepancies between the public libraries of Los Angeles and the Bay Area of Northern California. Foy's realm consisted of a book-room, a newspaper room, and a ladies' reading-room. Downstairs were various unscholarly establishments such as Benjamin's Boot and Shoe Store (which advertised its address as "67 Main Street, Downey block, under Public Library"). Also downstairs was one of the city's busiest saloons. Its habitués often made their way upstairs where they

Mary Foy was only 18 when she was appointed City Librarian, but quickly proved she was more than capable of handling the job. (Los Angeles Public Library Institutional Collection)

would ask Foy to settle ongoing bets on such questions as, "Who wrote *Webster's Dictionary*: Noah or Daniel?"

Mary Foy seemed to take everything in stride, including her wide-ranging roles as hostess to ladies who used the ladies' reading-room, and as mediator of the men's daily chess games. "Chess tables had been a part of library equipment since the day the reading-rooms were opened. The players lined up at the door at ten o'clock every morning, waiting for the librarian to open the doors, and they left reluctantly at five o'clock when the librarian was given two hours for refreshment and rest. At seven o'clock they returned to take their seats at the tables beneath the windows overlooking the patio of the inner court below."

Tourists were arriving in increasing numbers to Los Angeles and Foy made a special effort to reach out to them. "One of the great services of the Library in that day," she later recalled, "was to just act as headquarters for all the tourists who happened to be here. Anybody coming into any hotel in Los Angeles—any stranger in the city—all were welcome to take out books if they wanted them. I always saw that they left a deposit that was big enough to cover the value of the book they borrowed." She also encouraged serious researchers, one of whom was the young engineer William Mulholland. On one occasion she bent her own rules and allowed him to check out a reference book, explaining that he was "the first human being to come into the library to ask about anything that has to do with water."

She kept detailed accounts of library expenses and it is interesting to discover such budget items as "25¢ for ice to put in the tin water cooler and 10¢ for a lifter for the wooden stove lid." Foy was librarian until 1884, when she left to become principal at Los Angeles High School, later devoting her energies to women's suffrage. She recalled, "I have always been proud of my work as librarian of the Los Angeles Public Library, altho' it was such a small and *unscientific* institution and every possible office was included under one head."

In March 1889 a new Library board of directors was established by an updated city charter. The board was directed to "take charge of the Library and to conduct its affairs in the interest of the city." Within a few months the *Los Angeles Times* reported that "the directors have made a careful investigation of the property which was turned over to their care and upon such examination find that their sole possessions consist of about 5,000 books, many of which are of the trashiest sort, a few dilapidated chairs, broken-down tables, unbound volumes of newspapers, and three small, ill-odored rooms which few care to visit."

The board quickly determined that the Library needed new books, a new librarian, and new quarters. Soon a $10,000 appropriation was made for books, and a new and dynamic city librarian, Tessa Kelso, was hired. The board portrayed her as "a lady who has spent years in studying library work," but it was soon apparent that she was no ordinary Victorian lady. Within months of her appointment, Kelso impressed others as being "a brilliant woman who wore her

hair short, smoked cigarettes, walked down Broadway without a hat, and possessed encyclopedic knowledge about books and their authors." She also had a fiery nature and sued a local preacher for "moralizing about her in the pulpit." Regardless of her personal eccentricities, Kelso initiated a rigorous and able administration. Books were classified and catalogued, a training class for library assistants was established, printed lists and catalogues were published, a reference department was established, and the collection as a whole was improved.

Kelso and the board of directors soon turned their attentions to the problem of finding a new home for the Library which was growing rapidly, not only in collections but also in patronage. It was obvious that the old Downey block location was inadequate for any future growth and,

City Librarian Tessa Kelso was a powerhouse who vastly improved collection and reference services. (Los Angeles Public Library Institutional Collection)

after considerable discussion, the board of directors, with input from Kelso, recommended that the Library should move to "much improved quarters on the third floor of the new City Hall, an imposing red sandstone and tile structure on Broadway between Second and Third." The City Council agreed and plans were made to move the Library into the City Hall location by August 1889.

"The Library [was to be] closed for a period of two months, during which time the books were cleaned, repaired, counted, classified, numbered, book plates inserted, placed in position, shelf catalogued in duplicate, and a card catalogue begun," but by the end of summer the new quarters were not ready. The *Los Angeles Times* explained that "the new edifice cannot possibly be got ready before the 1st of September. The gas fixtures for the halls have not arrived yet, and the elevator is far from completed. In view of these facts, it was decided to defer the opening of the Library till September 1st, and in the meantime the newspaper reading-room in Downey block will be kept running." Expectations and impatience among the reading public were running high; on August 21, 1889, an exasperated library patron fumed in a letter to the *Times* that "because the Public Library has been closed so long during the progress of the changes ... the replenishing of papers in the Downey block reading-room has been much

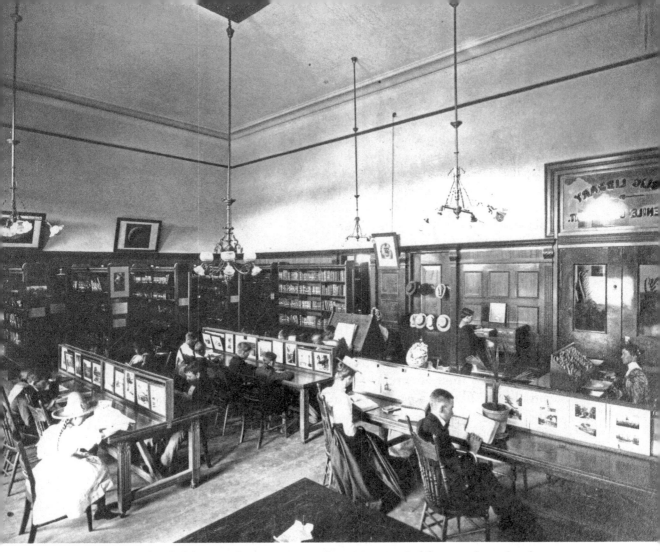

Patrons utilize the Library reading-room in 1890. From 1889-1906, the Library was located on the 3rd floor of City Hall at Third and Broadway. (Los Angeles Herald Examiner Collection)

neglected."

On September 2, 1889, the Library's new location on the third floor of City Hall was officially inaugurated and the *Times* enthused that "the reopening to-day ... marks the beginning of a fresh era in its existence." The Library's quarters were described in detail and it was noted that "the fittings of the rooms in the City Hall ... are on a scale of plain solidity, combined with artistic taste Everything is in white oak, and the effect is light and pleasing. The rooms are spacious, airy and well lighted; the principal room in which the books are contained is 70x50 feet; the general reading room is 75x30 feet, and there are besides two smaller rooms devoted, one to the use of the librarian and the other to the custody of the Patent Office reports and public documents....The ladies' room will be greatly appreciated for its air of comfort and convenience. It is nicely carpeted, well lighted, and is about 25x80 feet in size." The *Times*

FEELS LIKE HOME

concluded that "a casual inspection of the Public Library, in the new City Hall building, will prove an agreeable surprise to those of our citizens who have not yet been there. The improvements which have been made since the Library was located in the Downey block are remarkable. The Library, under the present management, is an institution of which Los Angeles may well feel proud." Equally proud was the Library's board of directors and they noted in their 1889 *Annual Report* that "we have now the satisfaction of seeing the Library located in spacious, well lighted and airy rooms, which have been furnished throughout with library fittings of the most improved designs and constructed of the best possible materials."

A month later, the *Times* reported that "the Library in the new City Hall has reading-rooms that are thronged day and night. The large, airy and comfortable rooms afford a striking contrast to those in the old Downey block, and there will be no difficulty about their becoming very popular." Additionally, "it is hinted that arrangements will soon be made for lectures on literature to be given to ladies in the ladies' reading-room." Another improvement was an elevator which promised to be "a great convenience to ladies, who dread three flights of stairs to the Library rooms." As it turned out, this convenience was not provided free of charge—the city charged the Library "$40 per month toward the expense of running the elevator between 9 o'clock a.m. and 10:30 o'clock p.m."

The new location did, indeed, attract "throngs of patrons" and circulation rose dramatically, from 4,833 in September 1889 (when the Library moved) to 11,076 one year later. Ironically, just as had happened a decade earlier, these increases were leading to space problems. The board's *Annual Report* for 1890 noted that

> "owing to the large addition [of new purchases] that has been made to the shelves ... we have found ourselves at this time in a dilemma on account of the limited accommodationSince the arrival of a large quantity of reference books in different departments there has been an increasing demand for examination of the same by persons who are evidently students, desirous of using the Library for the purpose for which it is intended. In order to give these people the accommodations they need for the examination of many books at a time, we have segregated a certain space, but find that it is entirely insufficient, and we think that this growing demand should be properly met, which can only be done by an extension of the floor space now at our disposal."

The City Hall location contained only 6,700 square feet and the board suggested that "if we had at our disposal the *whole* third floor of the City Hall we could establish a creditable reference department ... without this space it cannot be done." Tessa Kelso added that "the large number of newspapers from

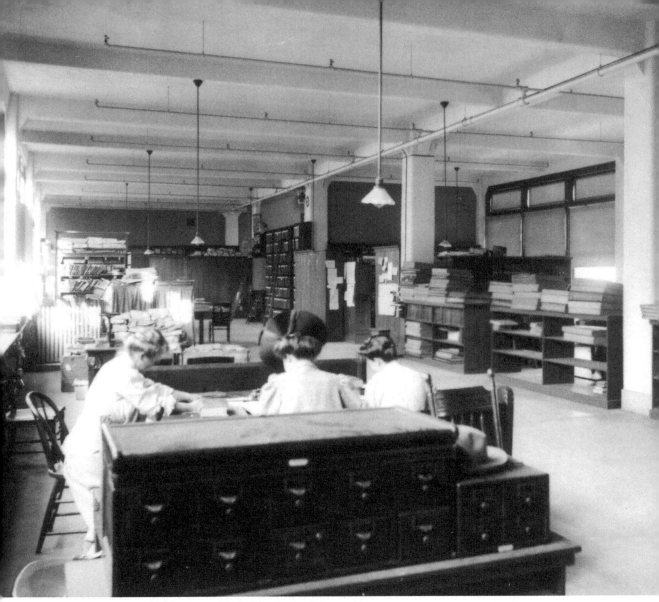

Another view of the Library at City Hall. Increasing collections and patron attendance quickly outgrew the space. (Los Angeles Public Library Institutional Collection)

surrounding towns, on file in the reading-rooms, required so much space that their continuance was deemed impracticable, and the donors of the papers have since transferred them to the Chamber of Commerce, where they are on file for use of the general public." She and the board agreed that more space was needed immediately and that "the time seems ripe for putting the Public Library into a building of its own, and to let it rank thereby with other public libraries in cities no larger than our own."

On July 1, 1891, the Library abolished its system of user subscription fees and was therefore made entirely free, "deriving its sole support from the

FEELS LIKE HOME

annual appropriation of a portion of the city funds, and from voluntary donations." The number of new patrons became a flood and, in 1893, the board again addressed the desperate need for larger quarters.

> "The demands upon the Library by the public have increased in astonishing ratio, the board has not been able, on account of the limited space allotted for the use of the Library ... to give that amount of satisfaction in the service which the public has a right to demand. Our crying necessity is for more room and better accommodations. It is a fact demanding recognition that the public requires better service than it is possible to render in the present cramped quarters....If the Library could be afforded sufficient space so that the books could be arranged in a way that would give convenient access to the shelves, the result would be the greatest accommodation to the public... If an arrangement could be made by which the Library could have more room in the City Hall, or be removed to a location where better accommodations could be secured, it would be of the greatest service to the public."

By 1895, the Library had 42,000 volumes, a circulation of 329,000 volumes, and more than 20,000 readers. Finally, in 1897, the City Council agreed to adopt the board's 1891 recommendation to establish "delivery stations in at least four of the outlying parts of the city, [thus reducing] the pressure upon the Central Library so much that it would be a great deal easier to handle the large crowds that come to the Library daily." Later that year, the Castelar reading-room was opened in the oldest and most crowded part of the city, near the Plaza; this was followed by the Macy Street reading-room in May 1898.

At the same time, the Central Library was still renting space in City Hall. Some improvements in the facility had been made and the Library board noted, in its 1896 *Annual Report*, that "the installation of electric lighting into all the [City Hall] rooms devoted to the Library use has contributed largely to the comfort of the patrons and the convenience of employees, the degree of illumination being very satisfactory."

Still, not everything at City Hall worked so well. On January 16, 1896, "the elevator in the City Hall came to a full stop and throughout the afternoon the throngs of Library patrons were forced to use the stairs to reach the Public Library....The city clerk, the day before, had informed the City Council that such an event would occur if he was not granted permission to purchase oil for fuel to keep the steam plant at the Hall in operation." In May, strange smells began to filter into the Library. The plumbing system was suspect and, on May 8, 1896, the *Los Angeles Times* disclosed that "the various closets, sinks and drains et al., in the City Hall [have emitted and] will continue to emit their noisome odors

City Librarian Mary Jones pushed for the Los Angeles Public Library to have a dedicated building constructed. (Los Angeles Public Library Institutional Collection)

for some time, as the sewer committee has decided that it will cost entirely too much money to even partially repair the plumbing apparatus in the building.... the health officer assured the city fathers that to force the Public Library girls to put up with the accommodations, or lack of accommodations, was simply cruelty to children."

Then, in October 1896, the electrical lights which had been publicized earlier joined the growing list of City Hall problems. George Stewart, chairman of the Library's finance committee, informed the City Council that, "On several occasions lately the electric lights provided in the rooms of the Public Library have been shut off for reasons unknown to the [Library] board, early in the evening; and in the absence of gas, has compelled the non-use of the rooms by the public, and has amounted to quite a serious inconvenience and detriment."

Another situation that should have been added to the list of problems was the Library's increasingly crowded conditions, an ongoing dilemma which the December 25, 1896 *Los Angeles Times* reported "undoubtedly keep away a most desirable clientage, and one from which the Library might have much to expect for its future growth....It is hoped that... a Library building with appliances worthy the name may at an early day decorate our city." No active steps were taken in that direction and, by 1900, it was again reported that "books were overflowing the crowded rooms of the City Hall [Library]. They extended to the attic and basement and were even lodged on the stairs. There was grave question of the safety of the floors under the weight of books. Documents were removed to the basement where these rooms were declared unsanitary for the lack of air, and the newspapers had to be housed in another building provided by the Chamber of Commerce The library board estimated that 50,000 square feet of floor space was needed for present library activities, while the City Hall quarters provided only 14,000 square feet."

Mary Jones, librarian at the time, was committed to relieving the over-crowded conditions of the Library and "arousing the interest of citizens in a Central Library building." In 1904, she proposed that a new Library be constructed in Central Park (now Pershing Square); a special election was held and voters approved the construction. The legality of this special election was contested by the City Council and the issue was fought in court, but John Wesley Trueworthy, president of the library board, stated, "It is expected that a decision will be handed down by the Supreme Court in April on the right of the city to place a library building in Central Park, in accordance with a vote of the people." He added, "I am confident that, if we can secure the park for a Library site, we can yet secure the gift of $350,000 for the erection of the building. The city could not buy a library site equal of Central Park for less than $2,000,000 We simply would add a beautiful building to the attractiveness of the park." The election and its results were upheld by Supreme Court decision in 1906, but plans to use the Central Park site were not given any serious

consideration by civic authorities due, in part, to "heavy bond issues for various lo-cal improvements and for the great enterprise of the Owens River aqueduct which have so far prevented the initiation of a specific campaign for a library building." The Library was forced to remain, as one reporter remarked, "still a wanderer and a homeless waif."

For the foreseeable future, at least, the Los Angeles Library would have no home of its own. Continuing to rent overcrowded quarters in City Hall was no longer a viable option, so the board of directors began a search for a new loca-tion. On January 11, 1906, the *Los Angeles Times* reported that, "The directors of the Public Library advertised for bids for temporary quarters for the Library, and last night opened the bids received. Homer Laughlin offered the board the two upper floors of the Laughlin Annex block, for a monthly rental of $850 for the first three years and $1,000 a month for two additional years, should the space be required for five years." Surprisingly, although a majority of board members favored accepting the Laughlin building, "some members of the board feel that it may be wise to retain these quarters [in City Hall] for the present" but they were outvoted.

On March 30, 1906, the Library completed its move to the Laughlin Annex, a fire-proof business building at Third and Hill Streets (next to Grand Central Mar-ket). The Library occupied four rooms on the upper floor and had storage facili-ties in the basement for a total of 20,000 square feet; there was also a 5,000 square foot roof-garden reading area consisting of "flowering hedges and fruit trees, and a section where men might smoke while they read." Incredibly, within only two years, the Library's facilities were crowded to capacity. It was reported that, "There is no room for expansion in the present quarters. It is reasonable to suppose that the use of the Library will keep on increasing....[needed book] stacks could not be put in the present quarters without spoiling the reading-rooms, which are already so crowded by patrons that if more books went in, a proportionate number of patrons would have to go out. It will be, under the most favorable circumstances, some years before a public library building owned by the city can be expected....During these years of waiting for its own library building the Library cannot afford to stop growing....Unless some change were made, there would soon be no place to put new books, nor to seat new patrons."

Again, the Library board found itself in the position of having to search for a new location. They moved quickly and, by the end of 1908, they closed a deal with the Hamburger Realty Company for space in a new building be-ing constructed at Broadway, Eighth and Hill Streets. This building was to be Hamburger's Department Store and the Library would occupy a large portion of the third floor. It seems like an odd choice but the building was enormous and was, for many years the largest department store west of Chicago. It was "not only fireproof, but heated and ventilated throughout by a modem blast-air system, both hot and cold, which will change the air every thirty minutes, and

**In 1906 the Library moved again to the Laughlin Annex at Third and Hill.
This location included a rooftop reading area. (Los Angeles Public Library Institutional Collection)**

at the same time enable patrons of the Library to inhale pure air at a constant temperature of 70 degrees." The site was also located in the burgeoning business district, and "every street-car line either passes the Hamburger building or transfers thereto, the building being almost in the exact center of the population of the city."

The Library was located on the third floor with access provided "by eight express elevators and an escalator, or moving stairway, which in itself is capable of accommodating about 4,000 people an hour." The Library occupied 31,000 square feet in the reading-rooms, possessed about 10,000 square feet for storage and binding purposes and approximately 28,000 square feet in the roof garden reading area, making a total of almost 70,000 square feet, compared with 25,000 square feet at the Laughlin building.

The terms of the five-year lease were certainly beneficial to Hamburger Realty, as the Library was required to pay rent of $18,000 per year. It was later charged that Charles Lummis, the librarian, was "business-like but not a businessman and the iron-clad lease he signed at an inflated rate was more

detrimental to the Library's future than the roof garden was advantageous. The move to the Hamburger building left the Library financially disadvantaged for some years to come."

The exterior architecture and decoration of the Hamburger Department Store was certainly beautiful but, for such a large building, the interior space was surprisingly cramped and ill-suited to the smooth movement of people and materials. The numerous large columns on each floor dictated the placement of furniture and, to an extent, the pattern of work flow. Oddly, one of the most nagging concerns for the Library administration was the fear that the public was starting to regard the Library as part of the department store and, in fact, the use of the collection was decreasing during the first few years at the Hamburger location. The Library board, in its 1910 *Annual Report,* observed that "as long as the Library continues to remain [at Hamburgers], it will not accomplish all the good it should. Situated as it is on the third floor of a large department store building, it appears to the ordinary passerby that, because of its unavoidable

The Library's wandering ways continued when it moved into the 3rd floor of the Hamburger Department Store on Broadway. Pictured here is the children's section.
(Los Angeles Public Library Institutional Collection)

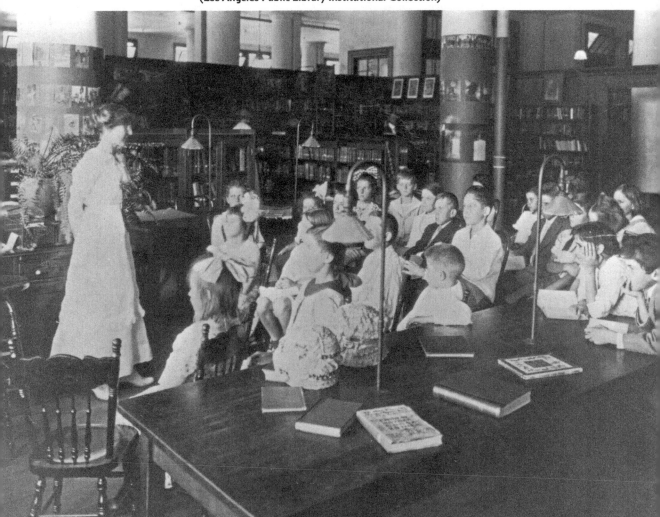

setting, it is a part of the department store itself....Many of its former patrons are no longer using the Main Library, owing to the inconvenience of its location. The best proof of this lies in the falling off of the circulation of the Main Library, notwithstanding the phenomenal growth of Los Angeles."

Having discussed several possible solutions, the board realized that, once again, the Library needed its own building, or at least a location which would be "library friendly." The option of moving to a site in Central Park was re-examined and the Library board concluded "that the ideal site for a new Library building is Central Park, preferably the Olive Street frontage, midway between Fifth and Sixth Streets. Such an arrangement would in no wise interfere with the beauty of the park and would do much in the direction of popularizing this institution." However, the Library was locked in by its five-year lease and had to remain at Hamburgers for the immediate future.

Not everything was bleak, however. In 1910, the Library received a gift of $210,000 from Andrew Carnegie "to be used in the erection and equipment of six branch library buildings." The board acknowledged the gift in its 1911 *Annual Report* and offered the hope that Carnegie's gift would inspire the public, thus "arousing civic pride to a degree that will provide a handsome Main Library building, comparing favorably with the buildings of Denver, Seattle, and eastern cities of less size and importance than Los Angeles, 'a consummation devoutly to be wished.'" Around the same time Mrs. Ida Hancock Ross (the widow of oilman G. Alan Hancock) bestowed, in her will, a gift of $10,000 for a memorial room in the new library "providing it is built within five years."

The Library clearly needed to move in a new and bold direction; the board itself moved in a new direction when it hired Everett R. Perry to replace Charles Lummis, who had resigned in 1910. Perry arrived in Los Angeles with ambitious plans for the rapid development of the Central Library and extension of service through the branches and deposit stations but, during his first visit to the Library, "he was shocked to hear the elevator operators call out the Library floors between the women's wear and the furniture, and, coming from New York, seems to have considered this as something of an excess of Western informality." It was clear to Perry that there were several challenges to be met and one of the most important was the ongoing, seemingly never-ending, space problem. Perry realized that, due to the Hamburger building's structure and layout, an extension or rearrangement would be impracticable; a move was imperative.

The Library board agreed with that assessment and wrote in the 1912 *Annual Report* that "development of the work at the Central Library has been greatly hampered ... [because] the arrangement of departments is inconvenient for attendants and the public. Only when the collection is housed in a new building of our own, so planned as to embody the most recent ideas in library construction, can the most efficient service be rendered." It was the unanimous opinion

Everett R. Perry became City Librarian in 1911 and would help drive the construction of a dedicated Central Library. (Los Angeles Public Library Institutional Collection)

of the Library board and Perry that the best interests of the Library could not be served by remaining in the Hamburger building. Because the lease with Hamburger Realty had expired, they agreed to renew the lease for one additional year while beginning the search for more appropriate quarters.

Recalling the various problems encountered in the Hamburger building, the board conducted a thorough and exhaustive search for a suitable building. After considering various options and suggestions, negotiations were made with the

owners of the new Metropolitan Building, then being constructed at Fifth and Broadway. A lease was signed for new quarters on the seventh, eighth and ninth floors of the Metropolitan Building at a cost of $22,000 per year (which, in terms of cost per square foot, was cheaper than the Hamburger building). The board was convinced that "these quarters will furnish most satisfactory arrangements for the Library until such a time as it is able to move into its own permanent quarters. The plan that has been worked out will give excellent elevator service and the best of facilities for all visitors to the Library and, owing to the convenience of its location, it is confidently expected that the Central Library will enjoy a much larger patronage than heretofore."

The move to the Metropolitan Building was completed on May 30, 1914, an occasion that prompted an anonymous wit to observe "that the Library had traded tenancy in a department store for rooms over a drug store." Nevertheless, patrons who visited the Library for the first time were duly impressed and the *Los Angeles*

While the battle for a dedicated central location raged on, the Library made one more move. The Metropolitan Building served as the Library's last temporary home from 1914-1926. (Los Angeles Public Library Institutional Collection)

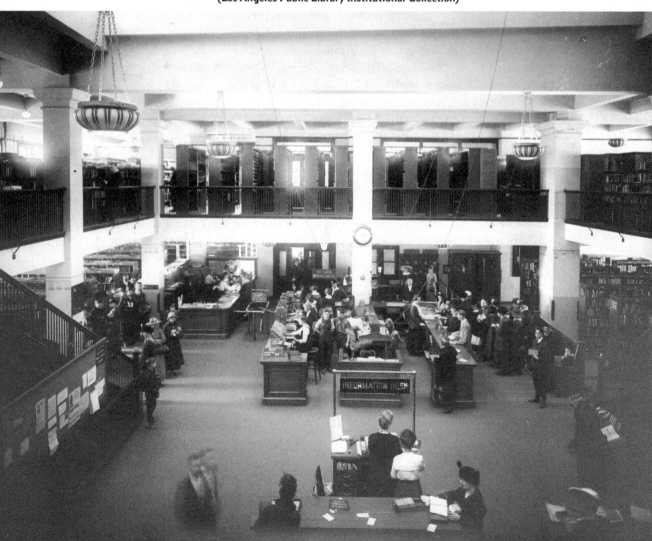

Times reported that, during the first weeks of operation, a great number of readers made the same remark: "At last Los Angeles has something that looks like a real library!"

The Library's *Annual Report* for 1913/1914 discussed the new quarters in the Metropolitan Building and listed some of the "many advantages both to the staff and the general public. The floor space is about 50% larger than in the old location. The Library now enjoys an abundance of light and air, and a highly accessible location in the very center of the shopping district, thus assuring the greatest convenience to its many patrons. The new quarters are completely divorced from any commercial enterprise, and have been most carefully planned by the librarian and his assistant to afford every comfort to readers. Owing to the improved arrangement all the books are now placed on open shelves, something much appreciated by the public. It was pointed out that the new lease ran seven years, but it was "confidently expected that the city of Los Angeles will provide a new building by the time of its expiration."

Floor plans indicate that the seventh floor contained the periodical reading-room, the Childrens' department, and the School and Teachers' department; the eighth, or main, floor contained the Circulation and Reference departments; the ninth floor housed the Industrial, the Sociology and the Art departments and the tenth had the administrative and staff departments of the Library, and the library school. There were, as well "special mezzanine departments, for all of which a single public entrance and exit is provided."

The Library operated successfully in the Metropolitan location for several years, its collection and patron base steadily increasing. By 1918, however, it was not surprising to read that the Library was beginning to run out of room. The *Annual Report* for 1918/19 revealed that "the location of the Main Library in the Metropolitan Building is not wholly suitable, and the quarters have become much too cramped for the best presentation of library facilities to the public. The lease upon these quarters is of short duration and the time is drawing dangerously near when definite and positive action must be taken for a change.... Besides being a handicap it is a stigma on the good name of Los Angeles to be obliged to rent rooms in which to house our Central Library, one of the institutions to which our citizenship should be able to point with special pride."

The Library, under Perry's leadership, began to press its efforts to educate the public on the need for a permanent home. It was a revelation to many citizens to learn that "the Los Angeles Public Library, after nearly half a century of constructive educational work and remarkable growth, [was] the only library of importance in the United States which has never had a central building of its own or has no such building in actual prospect. Perry wrote that there "must be developed a plan for a central site and new library building for the public library. The need of this has been discussed, understood and appreciated by those who know the facts,

for a number of years. We believe the time has arrived to act, and we are now preparing to go before the citizenship of Los Angeles and ask that a bond issue be voted to raise the funds necessary to acquire a new site and to build a library building suitable to the needs of the community."

The city responded to Perry's argument and, in 1921, a bond issue was passed which provided $2,500,000 for a Central Library building and branches. Then, in 1922, Normal Hill, the former location of the old State Normal School, was deeded to the Library by the City Council. Almost immediately, the *Los Angeles Times* reported, the city's welfare commission requested from the Board of Library directors a guarantee that "facilities for playground and recreational purposes be included in library plans for Normal Hill." Superintendent Raitt, of the Playground Department, asked, "If the request is refused what is to become of the hundred and one public interests that have been built up around this old Normal Hill Center?" But a more basic question faced the city: what to do with the old building which still stood on Normal Hill. It housed several city departments and the city was hard pressed to find another home for these departments.

A surprising and unwelcome announcement was soon made to the Library board: in spite of the fact that the City Council had deeded over the property at Normal Hill, it was expected that the library pay $100,000 to the city treasury to cover the cost of demolishing the structure which was standing there. A considerable amount of hard feelings grew between the Library board and the City Council and, at one point, Councilman Mallard labeled board members as "welchers" for their failure to pay. This antagonism was threatening the future of the new Central Library, as were the demands of a small but vocal citizens' group which opposed library construction on Normal Hill, insisting that the site should be in Pershing Square (formerly Central Park).

But the Library was too close to its dream to let the opportunity slip away, and cooler heads prevailed. On January 23, 1923, the city treasurer received the $100,000 from the Library board ("in the return for the gift of Normal Hill") and the agitation for the Pershing Square site faded away due to a lack of interest. The Normal Hill site was cleared and construction of the Library began, but it was not until 1926 that the dream finally became reality. The degree of public support and excitement was evident when, on June 19, 1926, "the crowd cheered when the moving van drew up to the Metropolitan Building ... to cart away the preliminary loads from the Public Library quarters to the new building, the permanent home of the Los Angeles Public Library."

This article originally appeared in a 2008 issue of The Communicator, *published by the Librarians Guild. A full bibliography for this article appears at the end of the book.*

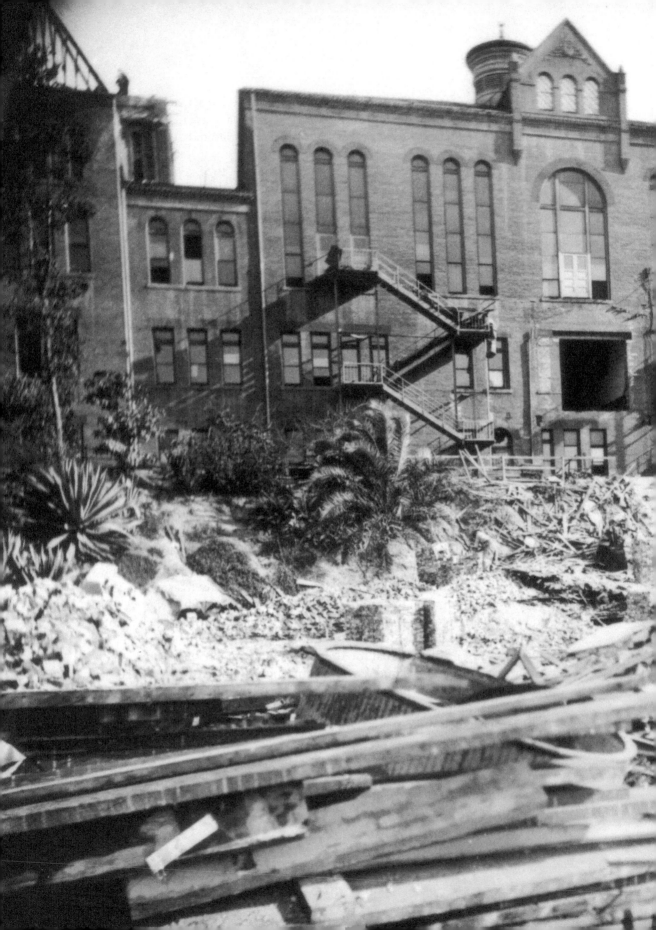

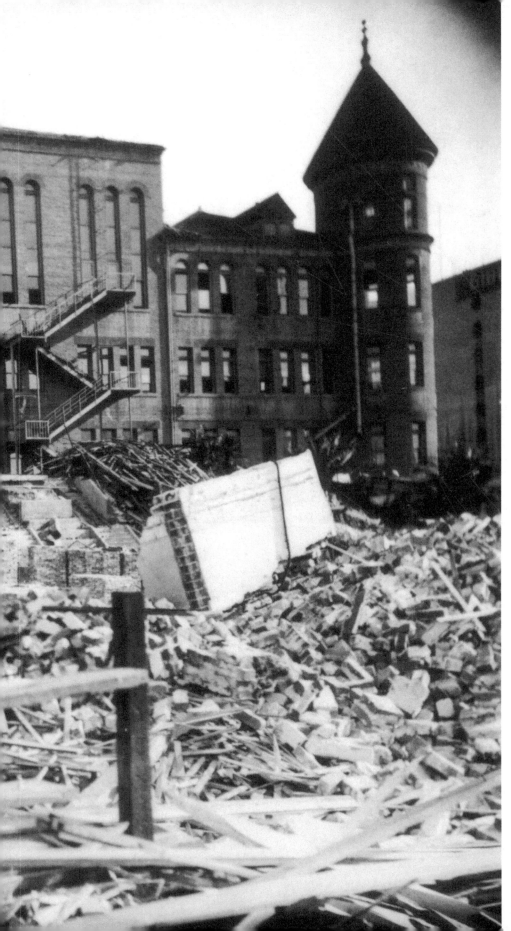

At long last, a home! View of the State Normal School in 1923 as it being demolished to make way for Central Library. (Security Pacific National Bank Collection)

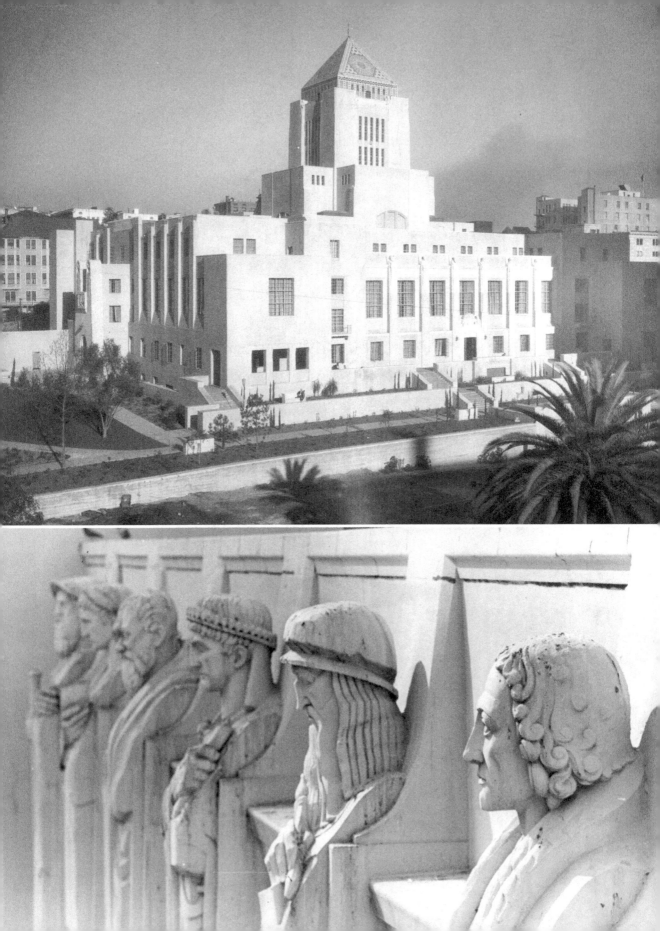

FROM BELLE TO BURDEN
AND BACK AGAIN

By JAMES SHERMAN
Librarian, Literature & Fiction Department

THE REOPENING OF the Central Library in 1993 was all the more sweet because it had dodged demolition too many times over the previous decades. Those who attended the opening in 1926 couldn't have imagined that what was then called "one of the noblest buildings in America" would too soon be considered a burden. For twenty years after its opening, the venerable building provided excellent service to the expanding population of LA, who made the library system tops in the nation in circulation. When the Great Depression hit, lines were so long that the entry had to be regulated. The City of LA's Central Library was an essential part of its metropolitan life.

The postwar population boom sealed the LA Metro area's status as the second largest in the nation, and pressures began to grow on the Los Angeles Public Library system in general and on Central Library in particular. The GI Bill ensured that the total student population was growing faster even than the regular population, and the rise of scientific and technical fields concurrent with the space race and the defense and aviation industries resulted in a proliferation of journals, and thus storage problems. Even as quickly as the population was growing—in the 1950's by 20%—the number of reference questions outpaced it, doubling during the same period.[1]

The once-beloved Central Library that had been a symbol of hope for the growing city had become a problem. Built for a staff of 200 and a collection of 300,000 items, it was now cramped for the staff of over 400 and collection of 1,250,000 items and growing fast.[2]

Opposite top: Once regarded as a gem of the city, by the 1960s Central Library was on the path to demolition. (Los Angeles Herald Examiner Collection) • Opposite bottom: (Anne Knudson, Los Angeles Herald Examiner Collection)

In December 1966, the Board of Library Commissioners produced "LOS ANGELES PUBLIC LIBRARY CENTRAL LIBRARY OF LOS ANGELES REPORT ON THE PRESENT BUILDING WITH RECOMMENDATIONS FOR A FACILITY TO MEET SERVICE REQUIREMENTS," better known as The Green Report (only because its cover was greenish in color). The Green Report recommended demolition of the Goodhue building and construction of a new modern building on the same location.

The Green Report summed up all the problems with the Goodhue building. The growth of collections had outstripped storage space, so that only 15% of books were available to patrons on open shelves, and about 200,000 books were offsite at a facility on Glendale Blvd. Retrieving those books could take up to a week. Because of these issues, circulation at Central Library dropped for the very first time, as branches, especially those in the Valley, were experiencing rapid increases in circulation.

The litany of problems posed by the old building continued: parking provisions were inadequate for the 54% of patrons who arrived by car.[4] The library couldn't maintain standards of service thanks to "delay and confusion" caused by storage issues, and those same storage issues not only resulted in damage to and deterioration of materials, it was liable to cause a "catastrophic situation in the near future." In addition, there was no space or ideas for new media, such as audio visual and microfilm. The Report is rife with pictures of patrons crammed at tables with no elbow room, contrasted with other cities' modern libraries which appear as spacious as an airport terminal. The Green Report went on to carp about the "ancient furniture, the poor lighting resulting in the inability to use typewriters," not enough electrical outlets, dilapidated rest rooms and, on a quaint human interest note, "no facilities for such ordinary comforts as a cup of coffee or a cigarette."[5]

This was the verdict from the commissioners and from librarians who had to work at Central Library: the place was terrible.

The Green Report suggested the answer: a new library, bigger and more modern, on the current location. This would involve tearing down the Central Library in order to construct a single-story behemoth on the site—specifically one with an open plan with large as possible horizontal space, open stacks, all functions under one roof, and onsite parking for staff and visitors. The Green Report's recommendation was for an independent building housing the entire collection on the minimum number of floors with maximum square footage for floors. The report was the official position of the library commissioners, and was to hang like the Sword of Damocles over the Central Library.

THE CENTRAL LIBRARY OF LOS ANGELES

A Report on the Present Building
(The Rufus B. von KleinSmid Central Library)
with Recommendations for a Facility
To Meet Service Requirements

Presented to the
Mayor and City Council of Los Angeles
by the

BOARD OF LIBRARY COMMISSIONERS

Mrs. Eileen M. Kenyon
Mrs. Leontyne B. King
Albert A. Le Vine
Albert S. Raubenheimer
Mrs. Mildred Younger

Harold L. Hamill
City Librarian

Los Angeles Public Library
December 1966

Title page for the 1966 Green Report which seemed to spell imminent doom for Central Library.

"The Library is a magnificent institution which nothing can hinder,
and nothing has ever tried to hinder, except peanut politics."
—CHARLES LUMMIS

"City Hall is getting its guidance from people who earn their daily bread
designing and building large buildings. Needless to say,
they are all for tearing down the old and putting up the new one.
Library management is totally committed to the same policy."
—JOHN WEAVER[6]

As befits Los Angeles, where everything seems to be a land deal, the call for a new library brought politics and money quickly to the fore. Many people, including City Council members, questioned the need for a Central Library at all. After a 1967 bond issue for library construction failed, City Council members said the city would never get a new Central Library through bond, and therefore it would have to be privately financed, with the idea that, "Branches stand a better chance by themselves because people hesitate to travel downtown."[7] Many saw a zero sum issue with the downtown library and the branches. Even as late as 1975, Marvin Braude of the City Council's finance committee said that the Central Library issue was divisive, and no funds were available anyway. "We're arguing purposelessly. The need to improve local library service is greater."[8]

The few Central Library proponents were silenced by powerful agendas. In 1969, the Southern California chapter of the American Institute of Architects (AIA) proposed preservation of the Central Library building with an underground connection to a new wing on adjoining land. But the City Administrative Officer, Dr. C. Erwin Piper, rejected the proposal, supposedly because it came with no funding plan. As it turned out, Piper had plans for a new library to be one of the anchors of a massive Skid Row redevelopment project.[9]

A big new library meant big money which created interest as well as problems. In 1970, RFPs for a new library were sent out, but builders declined the opportunity when they were asked to provide capital.

In 1974, the City Council, after investigating twenty-three possible sites for a new library, hired Charles Luckman Associates to do a feasibility study. Luckman and Piper had a special relationship: in choosing a contract for a Central Library—feasibility study and site selection in 1974, thirteen applicants were narrowed down to three. And after interviews were conducted, Piper ignored all recommendations and awarded Charles Luckman Associates the consulting contract to offer up sites for a new Central Library after "Piper had declared himself to be the only person with the power to decide."[10]

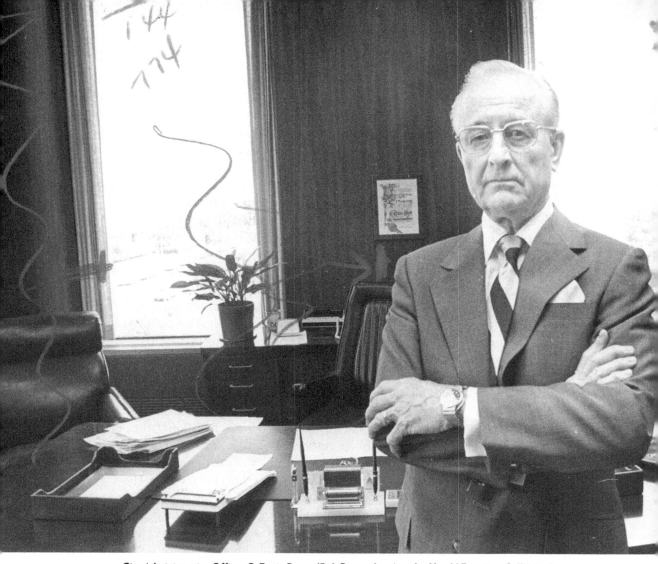

City Administrative Officer C. Erwin Piper. (Rob Brown, Los Angeles Herald Examiner Collection)

In 1976, Luckman presented his report to the City Council, narrowing down the sites to three locations—the library's present site; Bunker Hill (where juror parking currently is), which was preferred by the Community Redevelopment Agency (CRA), and a site east of Pershing Square that would extend through to Broadway, which was Piper's preference. It's perhaps therefore no coincidence that Luckman chose the Pershing Square site. While this choice would cost $83 million (and his company would receive $2.3 million to build it), Luckman claimed that restoring and expanding the old Central Library building would be impractical and prohibitively expensive, at between 35 to 38 million dollars. He stated that it was impossible to "remodel the present building or add to it," summing up that it was "a lousy library."[11] In addition, there was a discussion of selling the Central Library site as part of a plan to fund the new project; this had been the dream of prior Mayor Sam

Yorty. The proposals for both the Pershing Square site and the Bunker Hill site assumed the sale of the Central Library site to developers.

The Pershing Square/Broadway project was sunk by its enormous cost, the lack of support from the CRA, and organized protests by Broadway merchants.

In December 1976, the City Council, led by Zev Yaroslavsky, voted to instruct Piper to issue an RFP on a study of library rehabilitation and expansion. But Piper was a skillful bureaucrat in the service of his friend, and the RFP was never issued. Luckman wrote a letter offering to produce the study under his existing contract at no cost, and Piper sent the letter to the president of the council, John Gibson. Instead of putting Luckman's proposal in front of the whole council, Gibson sent it directly to the Recreation Committee, where council members Lindsay and Lorenzen, who had been supporters of Piper's Pershing Square plan, voted to accept Luckman's generous offer, and thereby skirted the City Council's request.[12]

Because the new study focused on Central Library's rehabilitation and expansion, the second Luckman report directly refuted the first. To explain his change of heart, Luckman partner Sam Burnett stated that, "we made the negative comments before we studied the old building... When we studied it in detail, we found it was possible to renovate, if done properly."[13] And apparently it could be done much more cheaply, by at least ten million dollars. Despite his sudden interest in Central Library, Luckman was still no preservationist: he stated that renovation of the old central section would involve a complete gutting—"It must be clearly understood that we are not talking about remodelling the building... you can't do it."[14]

This monster was to be paid from CRA funds, based on tax receipts. These funds evaporated with the passage of Proposition 13. Piper, approaching retirement, struggled to find funds for Luckman, and the project limped along. Somehow the Luckman study was becoming the plan for renovation—it was chosen among other applicants who had been given insufficient time and notice to prepare proposals. Luckman not only had the advantage of three years' experience and the support of Piper, but in one case, he was allowed to comment on the proposals of other applicants.[15] Beyond the inappropriate schemes to force Luckman's plan to become a reality, the images of the plan—most shockingly, those that show the rotunda violated with escalators—helped wake many people to the problem which preservationists had been addressing all along.

In response, the Southern California chapter of the AIA took the extraordinary step of filing a lawsuit on January 11, 1979, to stay operation of the Central Library expansion and renovation, and to set aside an invalid EIR to stop Luckman's "study" from becoming "the plan." The oft-ignored preservationists, cut out of the process for over a decade, had found their voice and their teeth.

Between The Green Report and the all-consuming political maneuverings, preservation efforts had been ignored in the quest for a large modern library. The Cultural Heritage Board designation of the library as a landmark in March of 1967

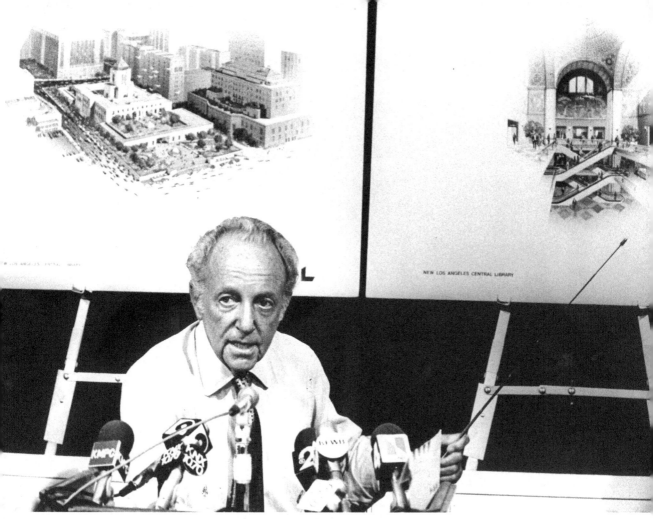

Architect Charles Luckman shows off his firm's vision for a renovated Central Library. (Los Angeles Herald Examiner Collection)

changed nothing, a 1968 AIA report for preservation of the library was ignored, a lawsuit to stop the destruction of the West Lawn garden for a parking lot in 1969 was unsuccessful, and the Central Library's listing on the National Register of Historic Places in 1970 (which was only the second listing in LA's history), seemed to have little sway when it came to plans to destroy the Goodhue building.

Certainly in newspaper news coverage at the time, there is a primary focus on the byzantine twists and turns of politics. On closer scrutiny, however, there were voices of praise for the existing building, from a Ray Bradbury letter to the editor ("The old library looks like Tomorrow itself...Outside of the Music Center, it is the only building downtown worth looking at"),[16] to more regular columns by architecture critics, most remarkably the sustained, clarion calls regarding the importance of Central Library penned by Joseph Giovannini of the *Herald Examiner*.

The AIA lawsuit was unprecedented and demonstrated the growing power and organization of the preservation movement. As motivated as they may have been on

A landmark designation at the city level did not prevent the 1969 demolition of the original West Lawn to make way for a much needed employee parking lot. (Los Angeles Herald Examiner Collection)

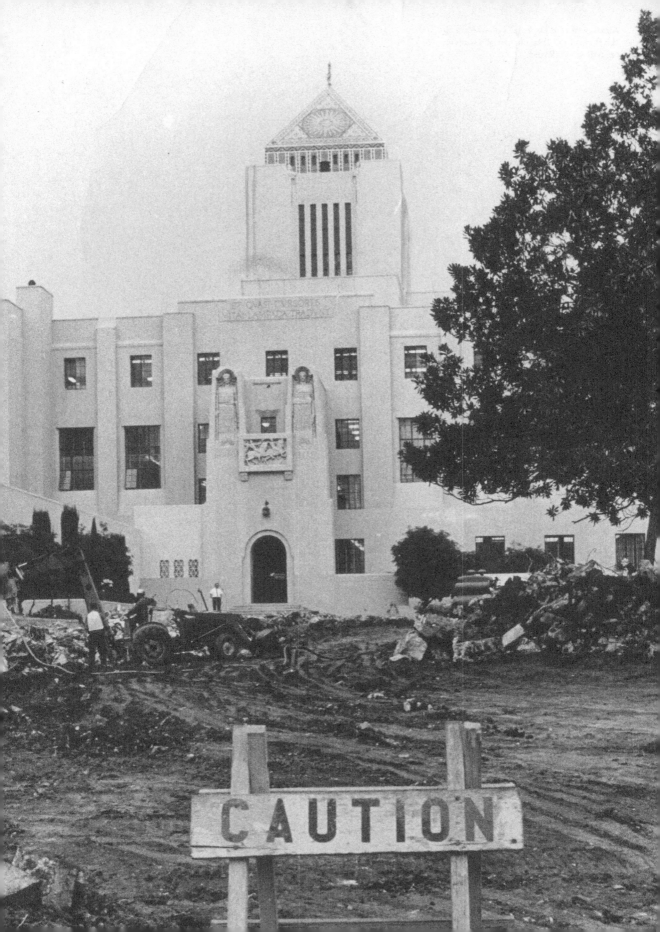

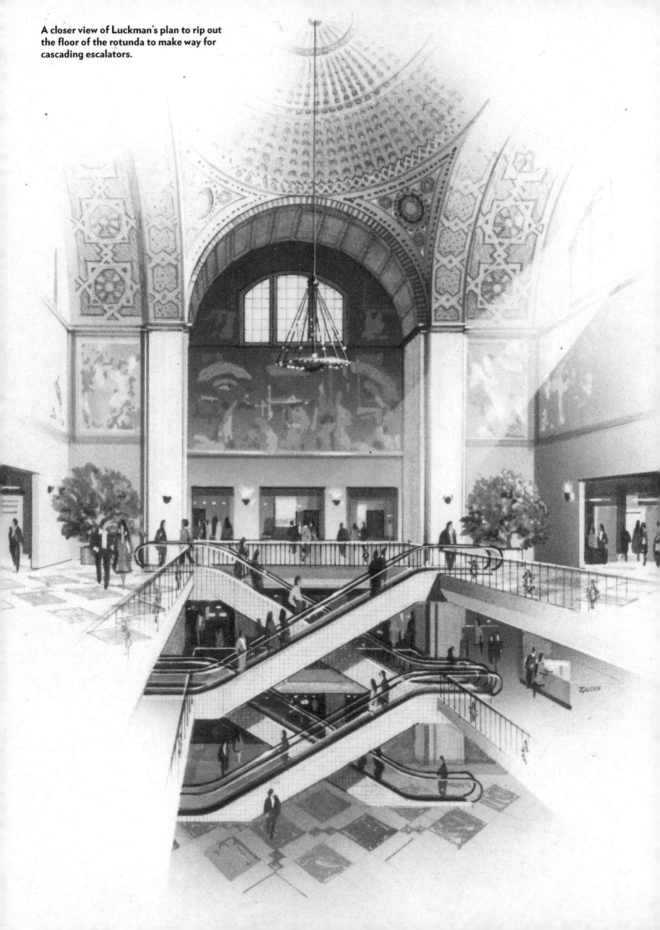

A closer view of Luckman's plan to rip out the floor of the rotunda to make way for cascading escalators.

aesthetic grounds, the AIA and their lawyers wisely went after the muddled process of city decision making. Apparently the City Council's certification of the EIR was not an approval of a project or alternative, yet somehow a notice of determination was produced by city officials that stated inaccurately that in fact the council had approved the project itself. The lawsuit was concurrent with the ire of City Council regarding the fact that the choice of Luckman and his design by the Board of Public Works was made under questionable circumstances and was thus highly problematic: Yaroslavsky informed Mayor Bradley of the complaints with the process, not in the least that other firms were given only one day for interviews.[17] The City Council voted successfully to put the final kibosh on the Luckman plan.

After the lawsuit, the AIA's Southern California chapter produced detailed guidelines for preserving the integrity of Central Library. This document was edited by Margaret Bach, who was later to become the head of the Los Angeles Conservancy, which played an important role in stopping the next attempt to destroy Central Library.

That attempt occurred in 1981, when a plan emerged that would trade development rights on the current library site to a private developer in exchange for a new Central Cibrary facility at effectively no cost to the taxpayers. The Library Board called again for proposals for a new library, and the preservationists realized again, as with so many past proposals, that these plans involved the sale of the library property for the cash strapped city, which would likely mean the demolition of the Central Library. One of the main plans discussed was two fifty-story towers on the space in return for a new Central Library gratis to the taxpayers: according to Joseph Giovannini in the *Herald-Examiner,* "the RFP disclaims any responsibility for the loss of the old library by mentioning the theoretical possibility of retaining the old structure," with no other mention that the building should be saved.[18] Giovannini further noted that library staff had drafted the RFP without consulting the L.A. Conservancy or the Los Angeles Chapter of the AIA: "...the case might be made that the librarians monopolized the initiative despite the documented interest of other parties." While the staff and patrons were the "identifiable users," there were "other legitimate custodians who were excluded from the RFP," such as the AIA and the Conservancy. Furthermore, the president of the city's Cultural Heritage Board, Dr. Robert Winter, noted that, "the first time the board saw the document was in January when 'it was already a fait accompli.'"[19]

In response, the newly formed Conservancy cut its teeth by initiating a successful telephone campaign to reach Mayor Tom Bradley and Councilmember Gilbert Lindsay,[20] the latter of whom had once called the library "disgraceful" and referred to it as a "heap of junk,"[21] but who now supported saving the Central Library. Times were definitely changing.

Along with attorney John H. Welborne,[22] the Los Angeles Conservancy was instrumental in forming Citizens' Task Force for Central Library Development "to

BOOKS ARE DOORS
INTO·FAIRYLAND
GVIDES·VNTO·ADVENTVRE
COMRADES·IN·LEARNING

THE·WORLD·IS·MY·BOOK

Joseph Giovannini, architecture critic for the Los Angeles *Herald Examiner* used his platform
to extol the virtues of Central Library. This image accompanied his 1979 piece subtitled,
"Why the library plan should be shelved." (Los Angeles Herald Examiner Collection)

seek a viable solution that addressed the functional needs of the library and the cultural significance of the historic building."[23] The task force included representatives from the CRA, downtown corporations such as ARCO, developers, architects, and city officials, including City Librarian Wyman Jones, who was asked to join the steering committee. The task force was successful in convincing Mayor Tom Bradley to delay the RFP process and instead to accept an offer of an outside consultant who ended up recommending the renovation and expansion of Central Library. But how? Who would have the ways and means for the project that had bedeviled city politics for so long?

Enter developer Robert F. Maguire III. Maguire was a regular lunch partner of ARCO's Robert O. Anderson, who would "often gaze down from his 51st story office and grouse about his shabby neighbor across the street."[24] Together they funded a plan to save the library, a plan that would win the hearts of the aesthetes, address the concerns of the politicos and leave untouched the taxpayers' purses.

Maguire was a combination of savvy and taste that had been missing in the first explosive growth of the sixties, during which developers were about the deal, not the building, and fostered an unfortunate "take the money and run" attitude.[25] Maguire was a different sort of developer, in that he brought a sense of aesthetics to his business practices, and with suggestions of I.M. Pei and Philip Johnson as his architects, he not only won over AIA, but also, as he himself later suggested, "... maybe I called upon the clout of east coast biggies to impress the local money men and politicos."[26] Like Luckman, Maguire didn't quail from political fray, with serious political donations and long-term personal connections, such as one partner who worked on Tom Bradley's gubernatorial campaigns. Unlike Luckman, Maguire was very good at building consensus and open process, to avoid the skullduggery of backroom dealing.

Even with these advantages, in 1980, Maguire lost a billion-dollar contract for Grand Avenue projects along Bunker Hill and so was looking for another high-profile project to take advantage of downtown's growth. It was natural that the library project became his focus. Maguire came up with the wherewithal in the form of a package worth $125 million to fund a sensitive renovation and expansion to the Central Library, in exchange for air rights that would support a massive development project on neighboring properties, which would include a building far taller than would normally be allowed.

While pitching his plan to civic and business leaders, Maguire was quietly and quickly buying up properties neighboring the library, including the Engstrom apartments property on the north side of Fifth Street. In doing so, he outbid and therefore annoyed a development company that was part of Rockefeller real estate investments, which owned an adjacent property crucial for the project. Maguire ended up with that too, putting himself far ahead of any competition for development of the library project. In the words of another developer, "Maguire was the

only one that close to the site."[27] His attention to aesthetics, commitment to open process, and shrewd business acumen resulted in Library Square.

Maguire's Library Square project built the monumental Library Tower (now US Bank tower) the Gas Company tower, and added the Bunker Hills Steps. For the library property, Maguire constructed an underground parking garage and helped transform the eyesore of the street level parking back to the beauty of the West Lawn garden, helping to make open space into green space again.

Maguire had managed to cut through the Gordian knot of the complicated project, and worked well with the CRA, which had been entangled for years over frustrated plans regarding Central Library. As CRA's Edward Helfeld asserted, "Without Maguire...we couldn't have done it."[28] He chose the ways, then the means: Maguire and CRA chose Hardy Holzman Pfeiffer to come up with a design that would truly preserve the historic structure. In 1985 the City Council, backed by the Los Angeles Conservancy, approved the project, and it seemed that fortunes had finally turned in favor of the Central Library.

Then, disaster struck.

Developer Robert Maguire III proved to be the creative saving grace for Central Library. Here, he is on the far left during a 1987 check presentation. Also pictured from left to right are Assistant City Librarian Tom Alford, Nelson Rising of Maguire Thomas Partners, Director of Central Library Betty Gay, Mayor Tom Bradley, Jim Wood, Chairman, Community Redevelopment Agency Board, and Library Commissioners Martha Katsufrakis, Ron Lushing, and Mary Lou Crockett. (Los Angeles Public Library Institutional Collection)

FEELS LIKE HOME

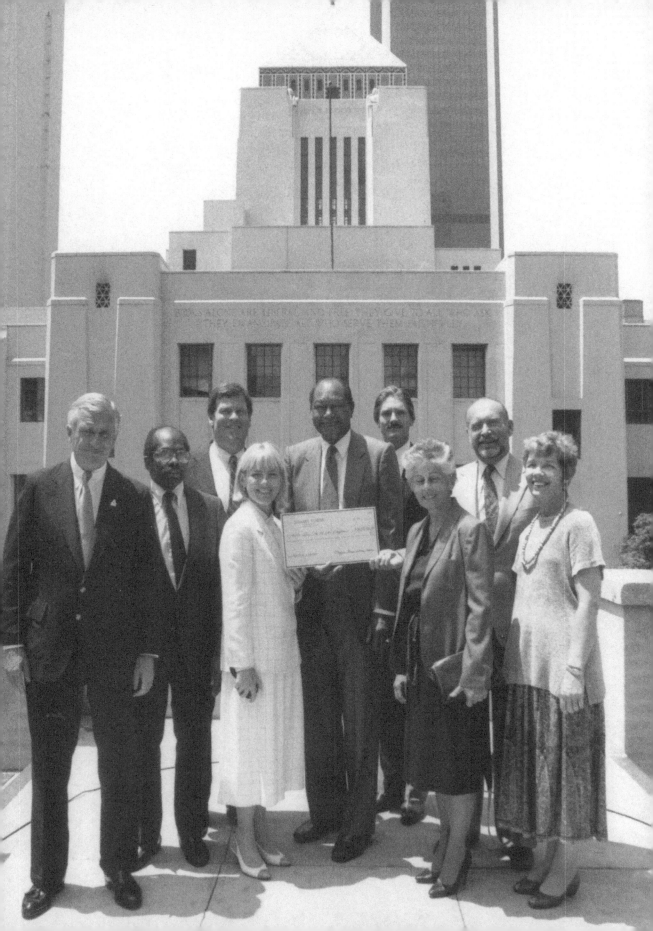

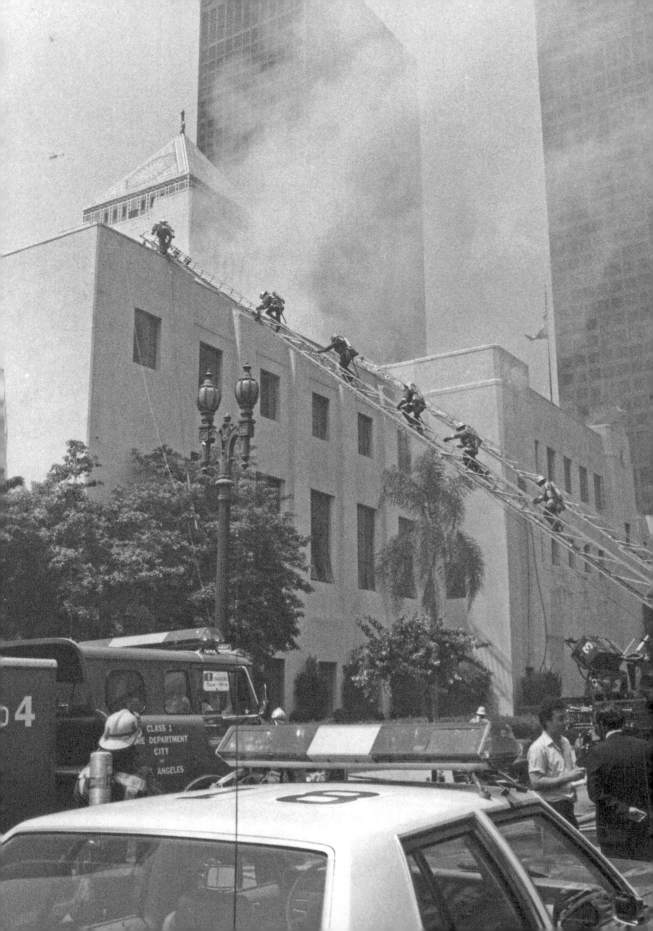

THE LEGACY OF
THE CENTRAL LIBRARY FIRE

By **CHRISTINA RICE**
Senior Librarian, Photo Collection

ON THE MORNING of April 29, 1986, librarian Dan Dupill was answering telephone calls at the Literature Reference Desk at Central Library. The antiquated phone system was slow, and the volume of calls high in those pre-Internet days, so getting through to a reference librarian could be a challenge. When the emergency alert started going off, Dan figured it was another false alarm that had become commonplace at the 1926 building. Rather than hanging up on the patron, who had already navigated the phone system once, Dan offered to put them on hold, figuring he would be back in ten minutes. It would be seven years before he answered another phone call at Central Library. He has often wondered just how long the caller stayed on hold before realizing that the building was actually on fire.

I started working at Central Library twenty years after two fires devastated the building and collections in 1986, yet "The Fire," as these events are commonly referred to around here, is a constant presence, even though it's been over 30 years since that dark day. The collections still bear the scars of 1986, with books and periodicals revealing their age and place through visible smoke and water damage, or by the unmistakable scent of fumes absorbed three decades ago. Phantom citations reside in the California Index, which point researchers to materials lost in the Fire, and I still contend with the damage done to the *Valley Times* image archive, where on two separate occasions, condensation formed in the drawers where the photos were stored. These tangible reminders of Central Library's fateful past are only one facet of the Fire's legacy, and while it may be easy to focus on these visible and devastating impacts, there are other legacies of the 1986 events that will be longer

Firefighters worked tirelessly to combat one of the worst fires in LAFD history.
(Los Angeles Public Library Institutional Collection)

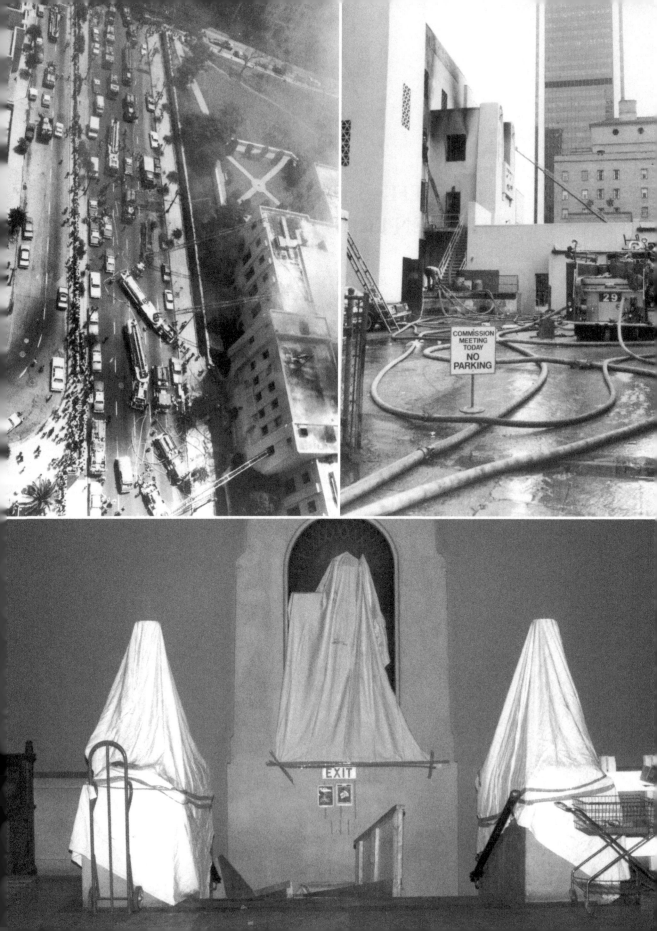

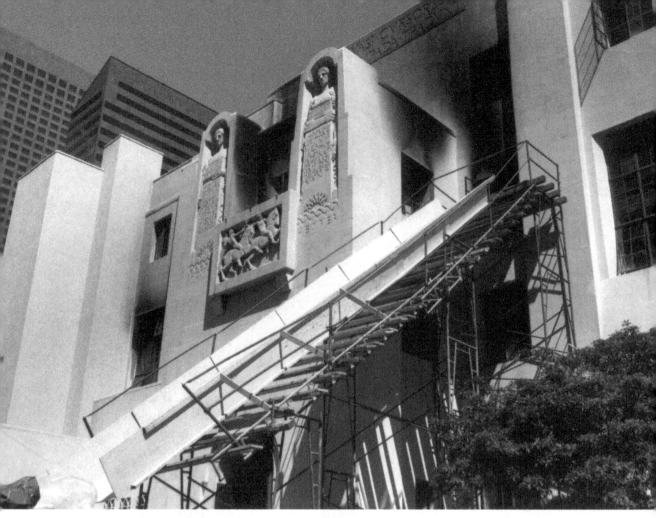

Make-shift slides are used to transport materials. (Los Angeles Public Library Institutional Collection)

will never take for granted.

For the staff, who worked round the clock in the immediate aftermath, the Fire also meant being displaced from their home-away-from-home and coming to terms with a loss of collections. Yet, living through the experience, working together, and emerging victorious seven years later created a bond between these staff members that is unique and continues to drive many of them to devote so much of themselves to the Los Angeles Public Library. I have heard many firsthand accounts of that time, some humorous, like the one of putting the phone patron on hold, and others tinged with great sadness. As much of a connection as I have with the vast and deep collections here at Central, I am frequently taken with the bond forged between staff members and Central Library that is impossible to comprehend if one didn't live through the events as a library employee.

Opposite bottom: The Sphinx and *Civilization* statues draped for protection during the post-fire cleanup. (Los Angeles Public Library Institutional Collection)

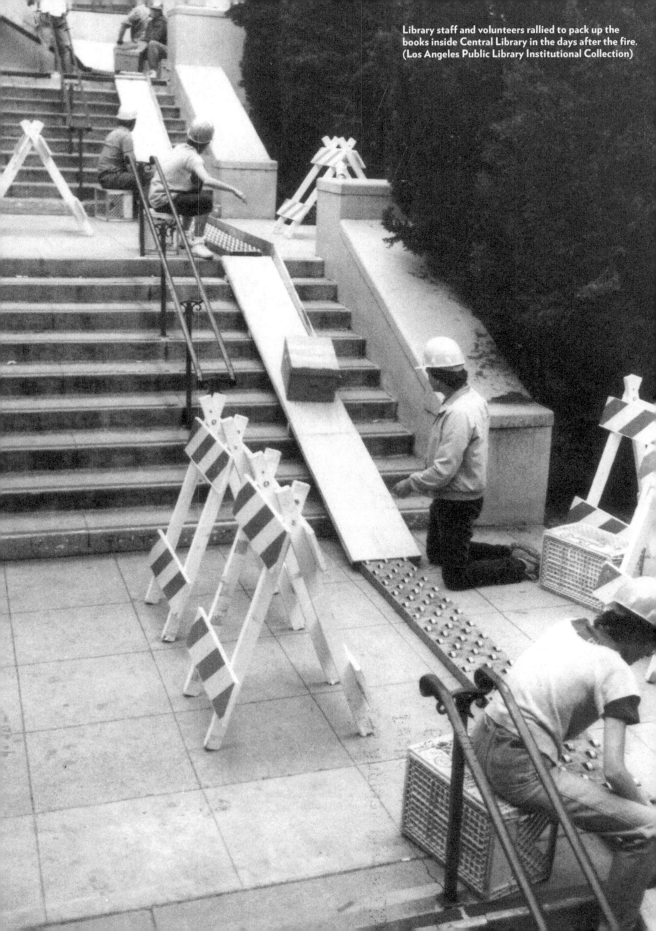

Library staff and volunteers rallied to pack up the books inside Central Library in the days after the fire. (Los Angeles Public Library Institutional Collection)

Central Library reopened 25 years ago, so it's easy to be far removed from its past. While a renovation of the building had been in the works prior to the Fire, and would have probably moved forward, the end result would have been vastly different. From these events came a new sense of purpose for Central Library as well as the Los Angeles Public Library system as a whole, and also lead to the formation of the Library Foundation, which has played such a large role in programming and fundraising.

The Fire at Central Library was an horrific event that shouldn't necessarily be celebrated but at the same time should never be forgotten. What can be acknowledged are the actions of thousands of people who rallied around a library to ensure that it would remain for generations to come. That is a legacy worth commemorating.

This piece originally appeared on the Los Angeles Public Library Blog on April 28, 2016.

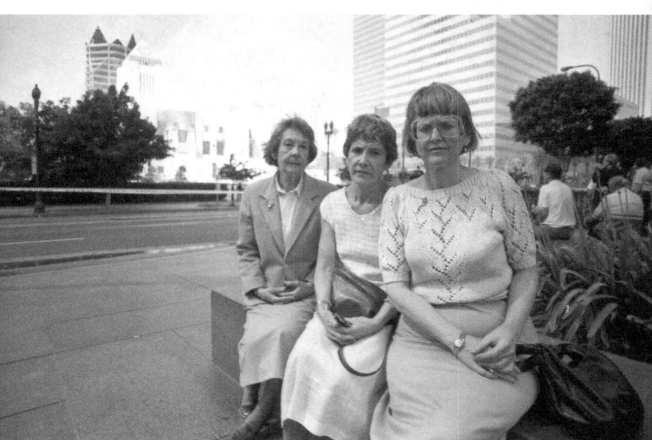

Librarians Kathleen (Katie) Leidich, Helene Mochedlover, and Billie Connor sit solemnly across the street from Central Library as the fire rages. (Leo Jarzomb, Los Angeles Herald Examiner Collection)

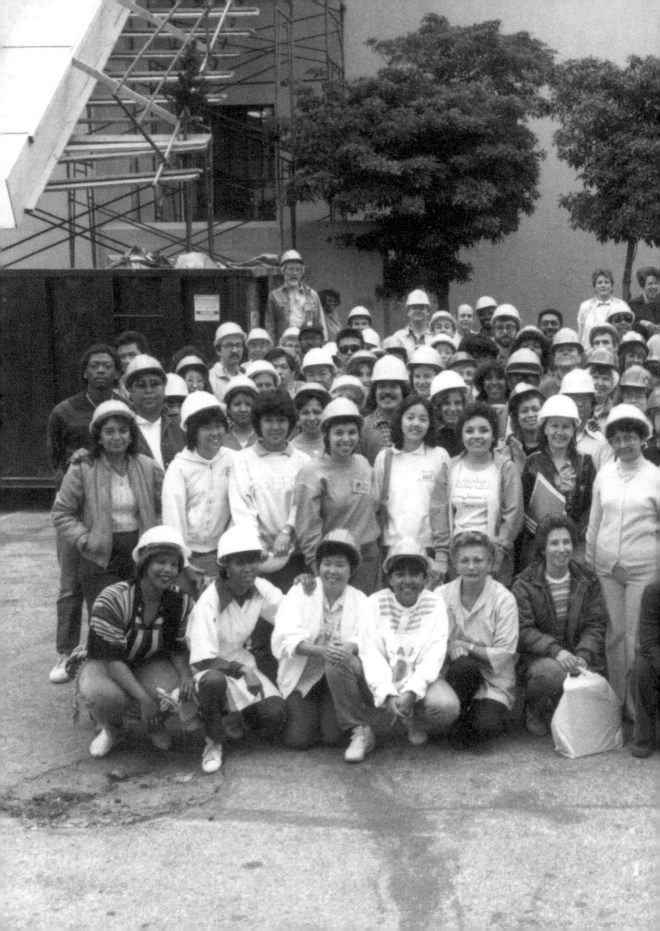

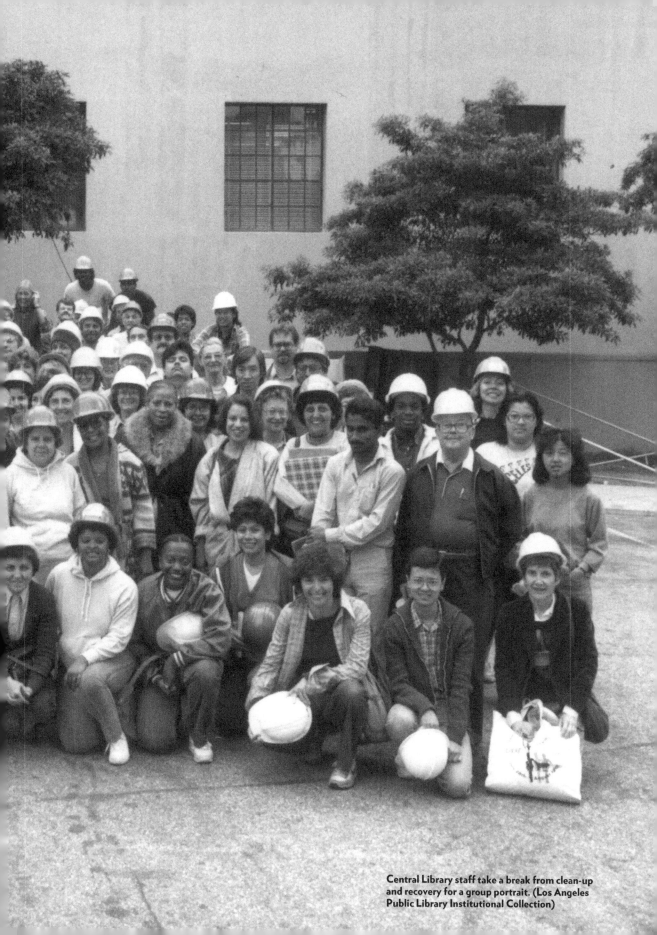

Central Library staff take a break from clean-up
and recovery for a group portrait. (Los Angeles
Public Library Institutional Collection)

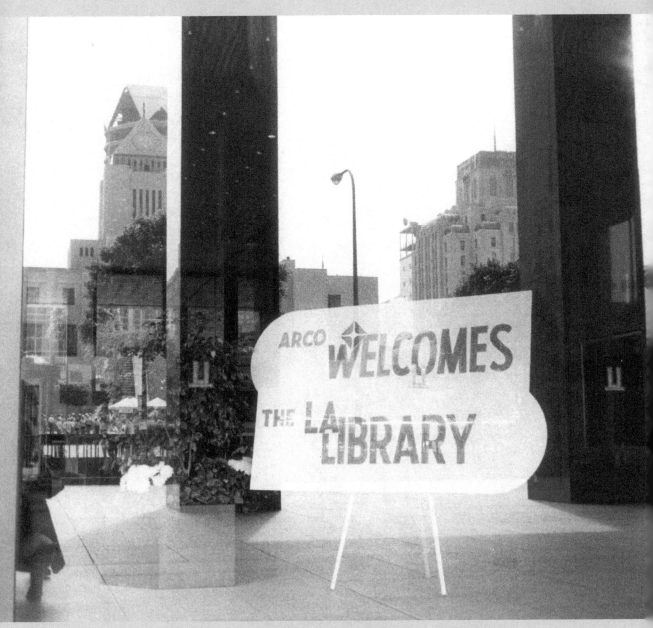

ARCO wasted no time in opening its doors to Central Library, first to provide space for an emergency phone bank, and then for temporary library administration offices. (Carolyn Kozo Cole, Los Angeles Public Library Institutional Collection)

SAVE THE BOOKS!

By SHERYN MORRIS
Librarian, Literature & Fiction Department

IN RETROSPECT it is ironic that the fire took place when it did, April 29, 1986. On that day, progress was quietly continuing with plans for renovation of the original Central Library and a new multi-level addition. Betty Gay, Director of Central Library, and Norman Pfeiffer, architect, were looking over plans, and the future for Central Library never looked brighter. For about twenty years, plans and proposals had dead-ended, and dire predictions about a major conflagration made by the Los Angeles Fire Department had done nothing to hasten a resolution that would satisfy various community groups. It is no exaggeration that many Angelenos had a lack of interest, even cynicism, about the future of the old building. Feelings, attitudes and community involvement were about to change—overnight.

ORIGINS

On April 29 1986, Carlton Norris looked down from the 32nd floor of the ARCO Tower, and saw the Los Angeles Fire Department, in full force, battling a fire coming from the west side of the Los Angeles Public Library's Central Library and thought, "Something has to be done to help the library." Even though he was an executive with ARCO, he had an extraordinary love and appreciation for libraries and librarians. With the approval from Lodwrick "Lod" Cook, ARCO's Chairman and CEO, phone banks immediately were set up on an empty floor of the building. The next day, April 30, 1986, ARCO invited library administration to occupy the 35th floor of the ARCO Tower. This would be the genesis for a major private and public effort to reach out and engage Angelenos in restoring what had been lost, and would prove to be a phenomenal success. However on April 30, 1986, library

staff and the public were in shock and could not think or feel anything but over-whelmed and devastated.

Very quickly, Lod Cook asked Carlton Norris to head a campaign and devote a major amount of time to raising money for books. Norris had never done fundrais-ing, so he hired a professional fundraiser, Jim Glass, but Norris also wanted librari-ans to be involved and turned to library administration for help. Betty Gay, Director of Central Library assigned Judy Ostrander, librarian in Business and Economics, and Sheila Nash, librarian in General Library Services to work at ARCO. The two li-brarians started working immediately with Carlton Norris. Later both of them were required by ARCO to go through a formal interview process to continue working on the project.

In asking librarians to be part of the project, Norris recognized and appreciated the expertise and knowledge that is involved in librarianship, and he knew how spe-cial Central Library was. In 1986, the library's collection was hard copy books and periodicals. There was a film collection, a vinyl collection known as LPs, but there was no automated catalog, only drawers of card catalogs. There was no internet.

Norris also knew that LAPL's Central Library's collection was the largest public library west of the Mississippi River, and had resources not found anywhere else in the United States, which is still true today. According to Kevin Starr, former state librarian of California, the Central Library has a collection distinguished, "... espe-cially in its depth of materials and therefore... manages to be distinguished, simul-taneously, as a collection and a public service agency." Starr recognized the unique characteristics of the LAPL system and stated, "A municipal library—even in Los Angeles, the original mega-horizontal city!—needs centrality, focus, institutional depth, if it is properly to serve its branches. Each and every branch, in other words, takes its strength, not from it own limited resources, but from the Central Library which backs it up."

STRATEGIES AND PLANS

The goal was "to raise $10 million in gifts and pledges to replace and enhance the collections burned or damaged in the original fire; to increase public awareness of Central Library; to build a constituency for future philanthropic support of Cen-tral Library." In order to do this, a "two-prong campaign" was to be enacted: major donor solicitation and general public appeal. The campaign definitely needed the expertise of the two reference librarians: Judy Ostrander's knowledge of businesses and directory resources, and Sheila Nash's knowledge of arts resources, both books and people. According to Judy, "Sheila Nash really knew the entertainment indus-try and the arts community (theatre, music, visual artists). She knew specific indi-viduals who would be asked to participate."

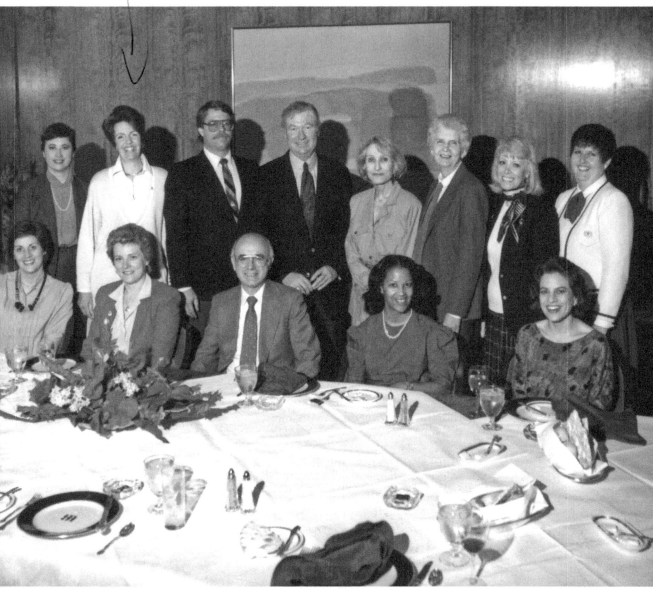

The Save the Books team who successfully raised $10 million to replace books damaged in the 1986 Central Library fire. Standing left to right: Carol Mangrum, Judy Ostrander, Bob Day, Carlton Norris, Pat Sadler, Iva Adams, Rosalie Pluth, and Beverly Monroe. Seated left to right: Betsy Bartscherer, Marilyn Ayala, Ed Desjardins, Cynthia Cook, and Sheila Nash. (Photo courtesy of Judy Ostrander)

The following campaigns and strategies were developed and implemented:

- Tom Yerxa, a staff artist, helped create a logo; press kits; bookmarks and bumper stickers; brochures; and slide/video presentations.

- A speakers' bureau of twelve librarians trained by ARCO, and armed with professionally designed packets of information and slide presentations, were sent out to speak to the public.

- A Save the Books gift shop was created with the first one in the lobby of the ARCO tower, and later another in the temporary library facility on Spring Street. Kiosks, built by the ARCO staff, were placed in other parts of downtown. A color catalog of items was published.

- December 1986, J. W. Robinson Department Store on 7th St. and Grand had all of its ground floor display windows decorated with "Save the Books" displays. Mrs. Tarlton and Mrs. Nash, mothers respectively of Judy Ostrander and Sheila Nash, helped with the displays.

- There was a telethon, a radiothon and a walkathon.

- By way of the *Los Angeles Times,* columnist Jack Smith helped to promote an essay contest, sponsored by KABC Talkradio and PAN AM which had an astounding response.

- Loderick Cook and Mayor Tom Bradley helped form a Save the Books Blue Ribbon Committee.

- A joint United Kingdom/Los Angeles Gala pushed funding over the top, with an appearance by Prince Andrew and Sarah Ferguson.

- A holiday card was created. It was an elegant simple line drawing silhouette of the proposed building: the original building and the extended addition as viewed from street level with the following message inside:

> *Season's Greetings on the eve of a new year—*
> *a time for each of us to turn a page in the book of life.*
> *But at the Los Angeles Central Library,*
> *there are 400,000 books with pages we cannot turn;*
> *they are in ashes, victims of an arsonist.*
> *In this season of rebirth, we*
> *want to share with you the opportunity to restore*
> *this collection to usefulness for everyone in our community.*
> *We wish you and yours a happy, healthy, and prosperous new year*
> *—and we hope you remember*
> *the Central Library collection*
> *in this season of giving.*

This card courtesy of ARCO.

SAVE THE BOOKS

This simples, yet elegant artwork was used on a mass mailed holiday card that resulted in over $135,000 in donations to the Save the Books campaign. (Graphic courtesy of Judy Ostrander)

A donation form was included with the card, and money was sent from all over the country and the world.

• A Collection Endowment Fund (for contributions of $25,000 or more) was established with benefactors' names on book plates, many of which can still be found in books at Central Library. Named collections include:

> *Architecture and Landscape Design: Maguire/Thomas Partners*
> *Banking and Finance: Bank of America Foundation*
> *Children's Picture Books: Security Pacific Foundation*
> *Civil Engineering: The Ralph M. Parsons Foundation*
> *Education: Milken Family Foundation*
> *Environmental Science and Technology: Southern California Gas Company*
> *Humor: KABC Talkradio*
> *International Picture Book Collection: The Riordan Foundation*
> *Motion Pictures: Mr. & Mrs. Lew Wasserman, MCA*
> *Opera, Operetta and Musical Theater: Lloyd E. Rigler and Lawrence E. Deutsch*
> *Real Estate: Ronald Lushing*
> *Small Business: Union Bank Foundation*
> *Unpublished Plays: Audrey Skirball-Kenis Theater*

• A Library Foundation was established to support Central Library collections after Save the Books concluded.

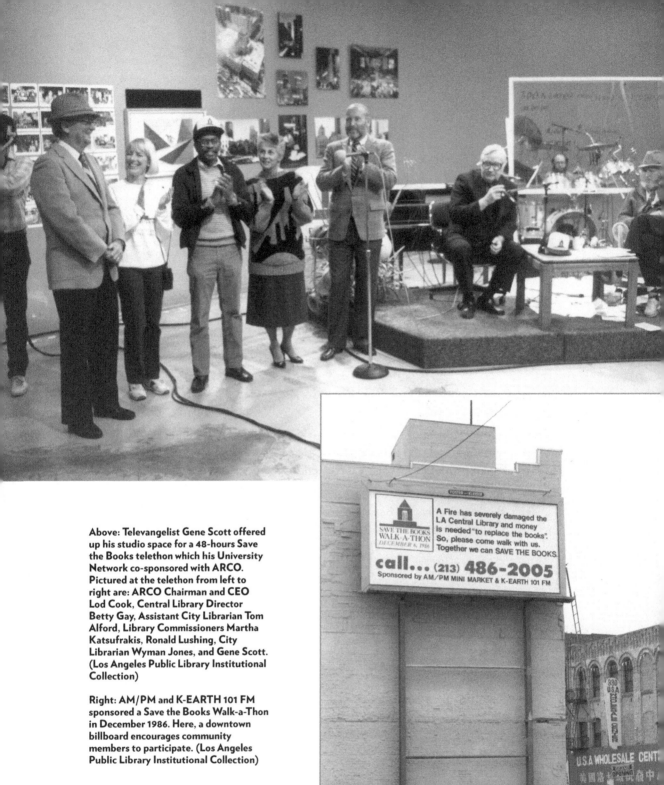

Above: Televangelist Gene Scott offered up his studio space for a 48-hours Save the Books telethon which his University Network co-sponsored with ARCO. Pictured at the telethon from left to right are: ARCO Chairman and CEO Lod Cook, Central Library Director Betty Gay, Assistant City Librarian Tom Alford, Library Commissioners Martha Katsufrakis, Ronald Lushing, City Librarian Wyman Jones, and Gene Scott. (Los Angeles Public Library Institutional Collection)

Right: AM/PM and K-EARTH 101 FM sponsored a Save the Books Walk-a-Thon in December 1986. Here, a downtown billboard encourages community members to participate. (Los Angeles Public Library Institutional Collection)

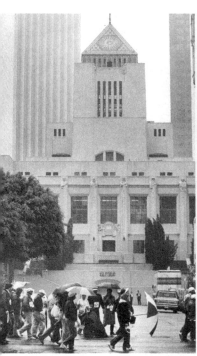 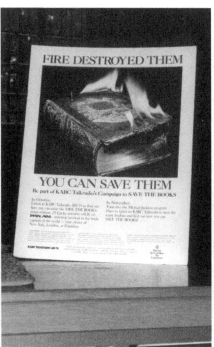 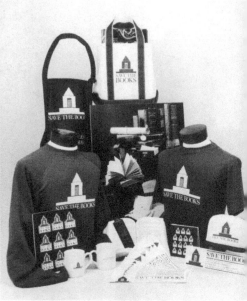

Above left: Walk-a-Thon participants stream past the Hope Street entrance of the shuttered Central Library. (Mike Sergieff, Los Angeles Herald Examiner Collection) • Above center: KABC Talkradio and PAN AM sponsored a Save the Books essay contest which resulted in a printed compilation. (Los Angeles Public Library Intuitional Collection) • Above right: A variety of Save the Books merchandise was made available for purchase as an additional fundraising activity. (Los Angeles Public Library Institutional Collection)

Below: Save the Books merchandise was available for mail order, but there were also stores set up in the ARCO building and in the temporary Central Library on Spring Street, pictured here. (Renny Day & Bob Day, Los Angeles Public Library Institutional Collection)

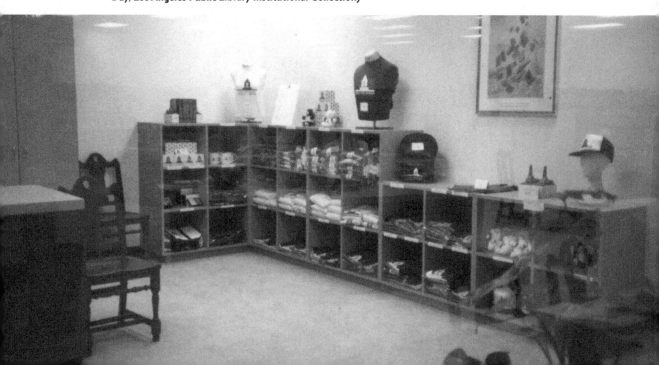

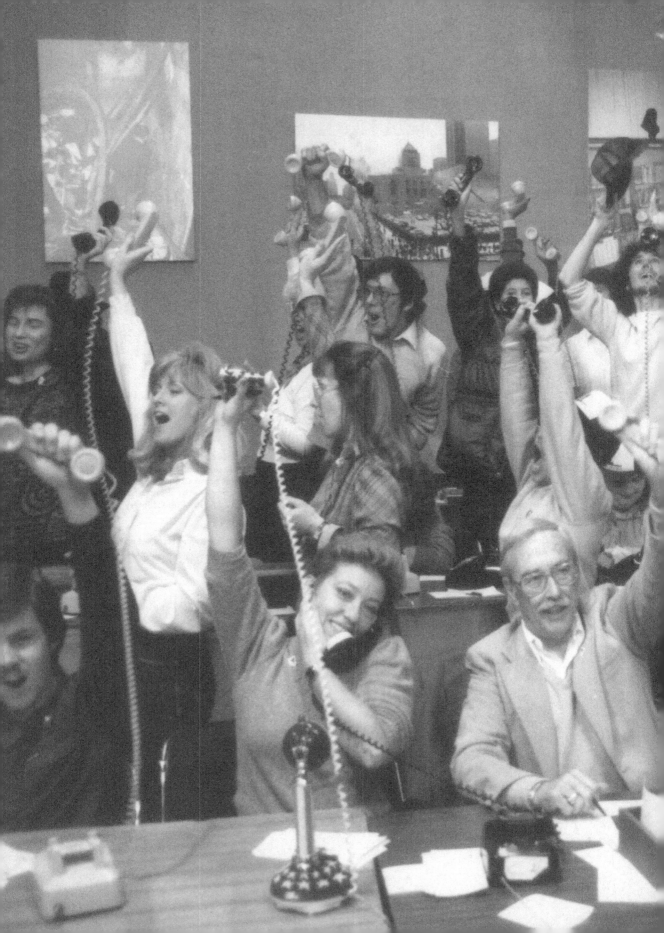

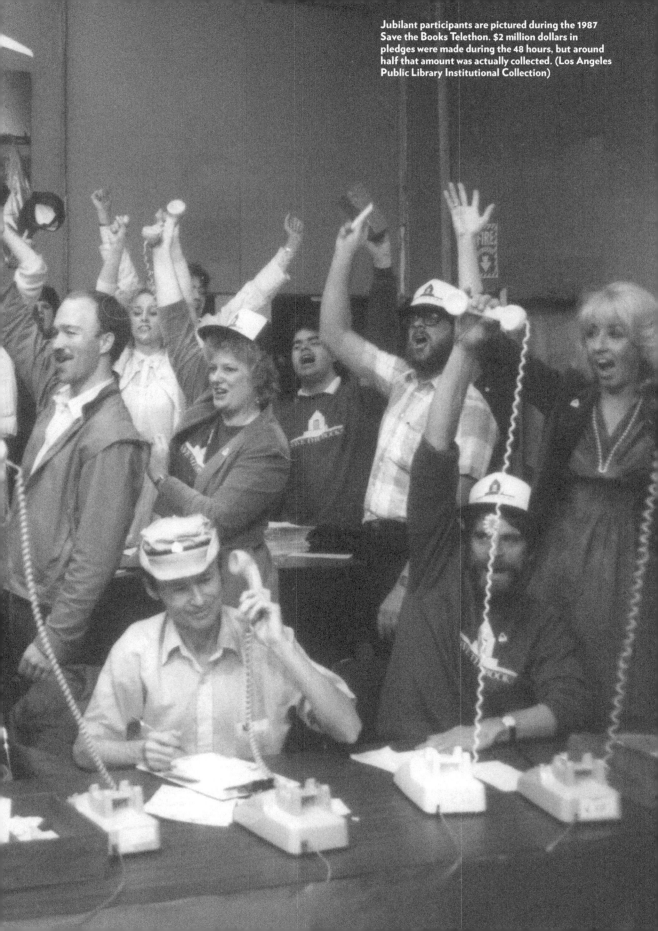

Jubilant participants are pictured during the 1987 Save the Books Telethon. $2 million dollars in pledges were made during the 48 hours, but around half that amount was actually collected. (Los Angeles Public Library Institutional Collection)

CONCLUSION

What was lost at the great library in Alexandria, Egypt is gone. What was lost at the Central Library, for the most part, has been replaced due to the diligence and dedication of numerous LAPL staff who worked on the documentation and organization of destroyed and damaged books; the initial and immediate response of people who came out in the hundreds to help sort, label and box books; and to the rapid response of a large private foundation that became the very model of a good neighbor to a large public institution.

The Los Angeles Fire Department stopped the fire. Carlton Norris and Lodwrick Cook quickly stepped forward. These two leaders helped initiate a professional and well-organized campaign to raise money that would be directly aimed at the purchase of lost materials (books, journals, newspapers). Through their professional planning they revived community interest in a major public library and its unique collection. Carlton Norris stated, "ARCO can easily give the library a check for 10 million dollars, but we want the people of this city to be part of this great endeavor." Save the Books came about in a time of great need. What felt like an ending on that ordinary day, April 29, 1986, turned into a community's renewed interest in a major informational and educational treasured resource, which continues to this day. The people of Los Angeles were awakened. Strategies and procedures were in place for what would follow, but that is a story for another time.

**A sign on the shuttered Central Library expresses thanks for community support.
(Los Angeles Public Library Institutional Collection)**

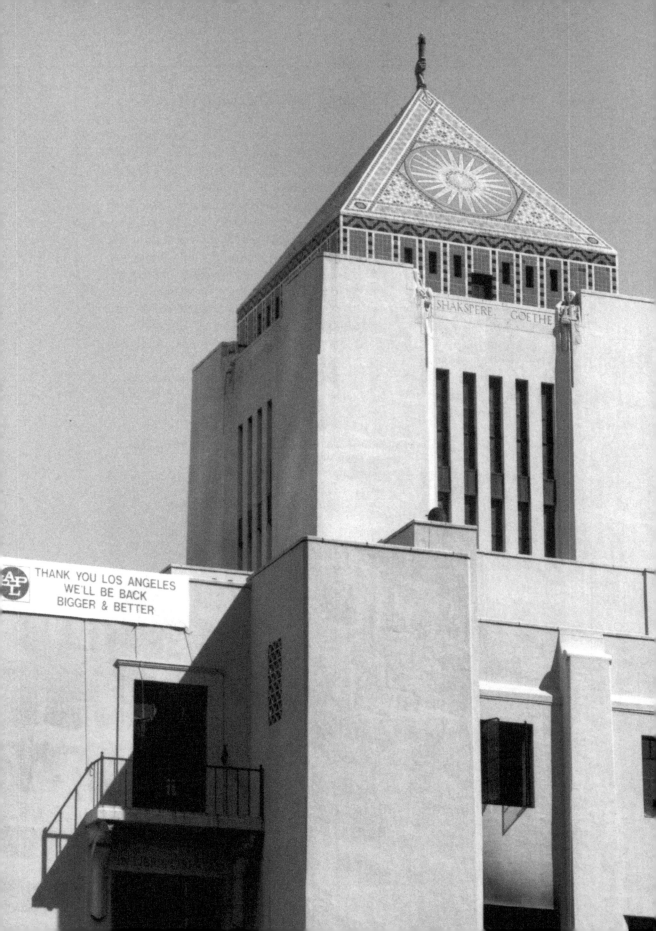

THE SAVE THE BOOKS LEAD LIBRARIANS

Judy Ostrander was a Librarian in LAPL's Business and Economics Department. She had organized workshops for the very active business community in downtown, and was dedicated to helping patrons connect with the great resources (all hard copy way back then) that were in the Business and Economics Department. According to Judy, "I wanted them to have a good experience and to come back. I wanted them to make a connection with the Los Angeles Public Library's Central Library, and they had to be in the building to do that." There was nothing like live interaction with patrons who could ask questions about previously unknown treasures that only an experienced librarian could provide. In addition, there was her methodology of utilizing resources found in other subject departments, such as the *Social Register* or *Blue Book*, and this thinking outside the box would be invaluable. Judy said, "The library is not the building, but the collection." The collection was created and maintained by the staff, and there is a melded relationship between the two.

Prior to working for LAPL, Sheila Nash had worked for Tandem Productions, organizing TV writer/producer Norman Lear's papers and company files, and as

Judy Ostrander and her husband Bill pictured during a Downtown Save the Books Walk-a-Thon. (Photo courtesy of Judy Ostrander)

FEELS LIKE HOME

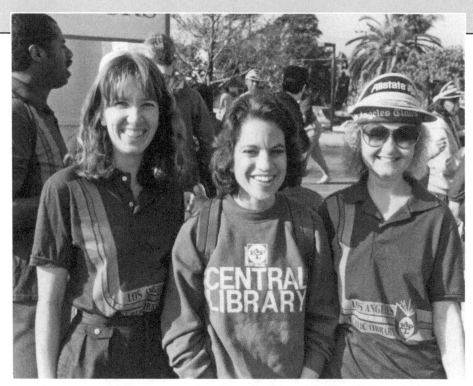

Sheila Nash (center), pictured during a Save the Books Walk-a-Thon in Venice.
(Los Angeles Public Library Institutional Collection)

a researcher for Tandem/TAT. She had cataloged exhibition catalogs for the Craft and Folk Art Museum; was a librarian and cataloger of German books at a community college; and at LAPL starting in January 4, 1984, she worked in General Reader Services and Generals Library Services. Sheila remembers being approached by Betty Gay, who asked her if she would like to work with the ARCO staff and another librarian on a fundraising campaign. Sheila said, "I was flattered and quite overwhelmed at the prospect. She let me know that Judy Ostrander would be the other librarian, and that is when I felt relieved and assured that with her expertise I could be of use."

Judy and Sheila worked on Save the Books from 1986 - 1988. During that time, these two librarians quickly established a very active routine, working closely on a daily basis with Carlton Norris and his staff. They created a plan to engage the people of Los Angeles in a giant fundraising campaign. Every day they worked on developing how to achieve certain goals, and at the end of the day would set new goals to be worked on the next day. Two Administrative Assistants, Ed Desjardins and Iva Adams quickly typed up all the proposals and ideas, including lists of individuals, companies and key contact people, social and cultural groups and organizations and their key people. As a working duo, the librarians were dedicated to the project and backed by the ARCO people.

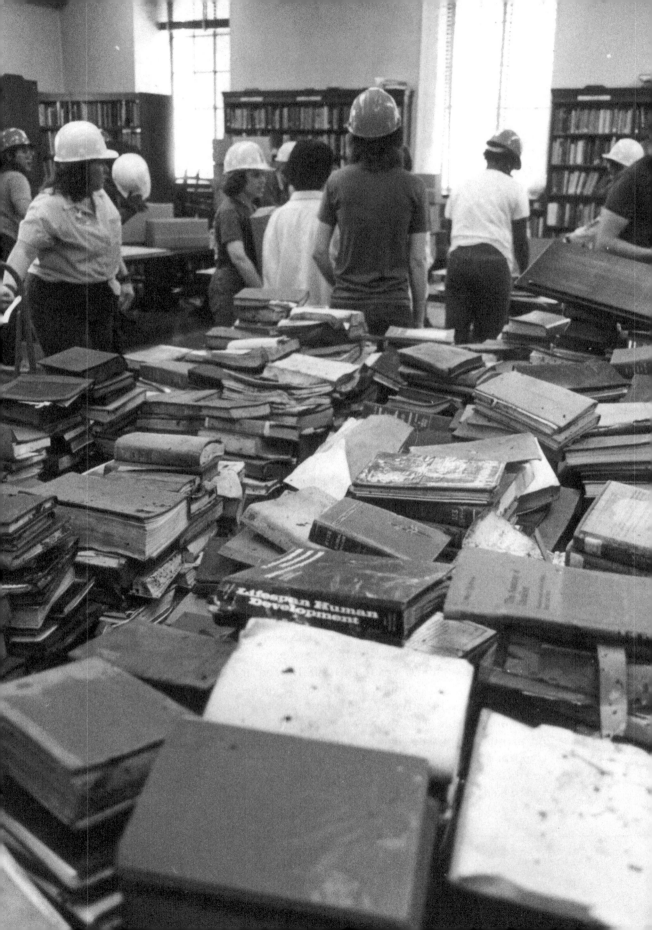

POST-FIRE MEMORIES:
RIO VISTA, SPRING STREET, ETC.

By BOB ANDERSON
Librarian, Literature & Fiction Department

IN THE AFTERMATH of the April 29th fire, most of the Central Library staff continued to work in the dusty, smoky building for over a year, at least part-time. The post-fire volunteers had packed up most of the books in the building's closed stacks, but those in the reading rooms, which had almost no smoke or water damage, remained on the shelves, as did those in a few places in the stacks that the Fire Department had declared off limits. Once the initial rush was over, the staff eventually began to inventory and box these remaining books. The inventory was done using cards from the card catalogs in the various departments, since it was clear that those catalogs were never again going to be used for their intended purpose, with so much of the collection destroyed or damaged. After a week or so, we were also given permission to pack and box some of the volumes in the areas that had previously been declared off limits. I know that this process took a number of months, because when the mysterious second fire took place in the music department reading room early in September, those books were still on the shelves and were either destroyed or damaged. The staff also worked on other projects like ordering new books and converting some of our card indexes to Inmagic files. (We had just a handful of computers in the building, and of course all these new files had to be backed up daily on floppy disks.)

Administrative staff were offered office space by ARCO across the street, so they moved over there, and SCAN eventually relocated to UCLA. The catalog department moved to offices in what was then the First Interstate Tower (now the Aon Center). The weekly branch book committee meetings (where a rotating committee

Central Library staff pack up piles of books. (Los Angeles Public Library Institutional Collection)

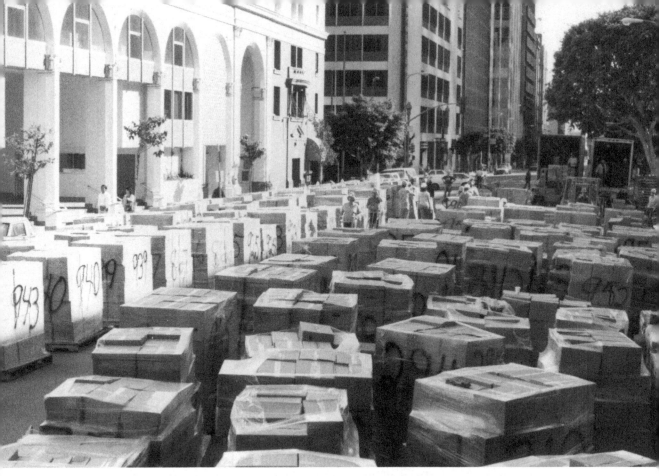

Boxes upon boxes of packed books lined up on Hope Street, ready for disbursement to multiple locations. (Renny Day & Bob Day, Los Angeles Public Library Institutional Collection)

of library staff decided which Central Library purchases should be listed on the branch order sheet) was moved to the office of Barbara Jacobs, head of Acquisitions, at the library's Anderson Street building. The new books that continued to arrive were boxed up after being cataloged.

While all the water-damaged books had been sent off to cold storage for eventual freeze-drying, there were pallets and pallets (many hundreds of thousands) of dry books that had to be stored for an extended period of time, so eventually the Rio Vista warehouse was located for that purpose. Rio Vista Street is the first street east of the Los Angeles River (thus the name) off of Olympic Blvd. The warehouse was a one-story structure in a neighborhood of other warehouses (plus the old Sears building on Olympic at Soto). It had a fairly small office at the front, and a loading dock, and the rest was just open floor space. Once the books had been moved there (along with the departmental card catalogs), Central Library staff started going there a couple of days a week to inventory (and clean—many of the books had smoke residue, etc.) all those volumes. We were all assigned to certain shifts (Mon-Wed and Tues-Thurs), I think, and librarians Rolando Pasquinelli and Linda Moussa were in charge of the operation on alternate days. This schedule of part-

FEELS LIKE HOME

time at Central, part-time at Rio went on for quite a few months.

Eventually (it was pretty far into 1987 by this time), all the furniture had to be moved out of Central Library, plus the staff who still worked there part-time. Leslie Nordby (at that time the Principal at Municipal Reference) was in charge of the various move operations that occurred, and Jane Nowak (the Senior in Fiction) was in charge of getting everything packed up, which entailed a lot of committees, a lot of meetings, the design of labels designating what department every piece of furniture belonged to, etc. Much of the furniture went to another warehouse, this one multi-story, not too far from Rio Vista. I was only there once or twice so I can't remember exactly where it was. Frank Louck and Dave Cerlian were the ones who spent the most time there. Much of the Central Library staff also moved full-time to Rio Vista, along with just enough furniture to give them a place to sit and work. This was mostly tables and chairs from the library reading rooms. Each department had its own little area (a few tables with chairs facing each other) which we called pods. There was not enough room for the entire staff, so some librarians and clerks were temporarily reassigned to branches. I went off to Municipal Reference at City Hall East, where I worked at their reference desk and also spent time ordering fiction materials and adding to the California fiction file on Inmagic. One day a week I would go to Anderson Street, where I worked on the many gift books received in

Staff work in less-than-optimal conditions at the Rio Vista warehouse.
(Renny Day & Bob Day, Los Angeles Public Library Institutional Collection)

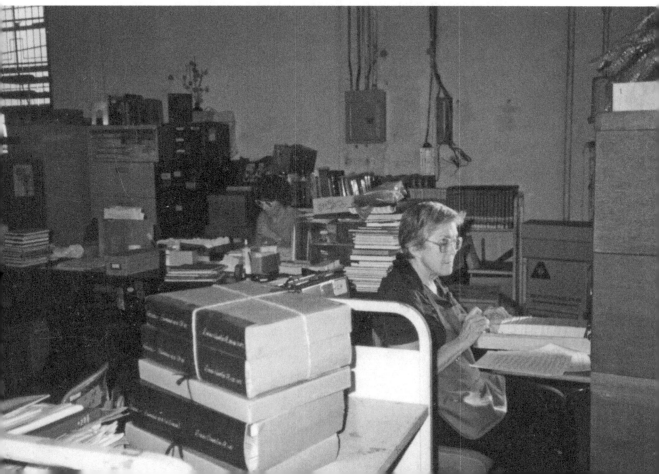

the aftermath of the fire. Since we had only a vague idea of which books had survived, we added pretty much any gifts from the areas of the collection we knew had major fire and water damage. We kept a card file of the items we'd added, in order not to end up with fifteen copies of best-sellers. After a few months of this, Jane Nowak was promoted to Principal in History, and I moved over to Rio Vista to be acting senior and stayed for the duration.

The Rio Vista building certainly had its disadvantages, but it was not all gloom and doom. We did have perhaps three computers to continue our work on the Inmagic databases. I remember going through a *Wilson Fiction Catalog* and marking it for a big order of classics to be purchased with Save the Books money. One of the librarians, Stephanie Beverage (later director of Huntington Beach Library) would hold a daily exercise class for staff. Sometimes a group of us would walk down Soto to have lunch at Mike's Hockeyburger; other times we ate in a bit more style at the nearby Rusty's Hacienda Mexican restaurant. Many of us substituted at branches from time to time. And, at burned-out Central, Rio Vista, and Spring Street, the Children's Literature staff periodically entertained us with morale-boosting puppet shows in which the various puppets represented members of the staff—including, of course, library administration. Almost everyone (even me!) became a puppet show character at one time or another. We got all the dry books inventoried, and also went through a lot of smoke-damaged periodicals, tossing any that did not have pictorial value and could be replaced with microfilm.

Meanwhile, since the renovation of Central Library (already in the planning stage before the fires) would take a number of years, the question of where a temporary Central could be opened was unresolved for a long time. Administration looked at various downtown buildings (and at that time there were MANY vacant offices buildings downtown), but most had to be ruled out because they were not constructed to hold the weight of all those books and shelves. At one point we were supposed to move to the old Bullock's department store building, but not long before we left Central that plan fell through and when we dispersed to Rio Vista, branches, etc., we had no idea when or where Central would reopen. Librarians Helene Mochedlover and Renny Day often wrote theme songs for this era based on classic show tunes, and I remember the one at the final party/puppet show at old Central was based on the *Paint Your Wagon* song: "Where're we goin', we don't know; when'll we get there, we ain't certain, all we know is we are on our way."

Eventually, the 1928 Title Insurance and Trust Building (then known as the Design Center), at 433 S. Spring Street, was secured as the temporary library. It was decided to have the Central Library staff do most of the reshelving of the collection, which was a huge project—like putting together the pieces of a gigantic jigsaw puzzle. While the building was being configured with book shelving, the Central Library staff began a new project—cleaning and inventorying all the freeze-dried, water-damaged books. At this point, a large crew of messenger clerks was hired to

assist, since most of Central's messenger clerks had moved on to other jobs post-fire. We did this rather unpleasant job in a building right next to the Design Center. For a number of months before the move, the library opened a "Popular Library" type facility called the Spring Street Book Stop on the first floor of the Design Center. The library occupied most of the building, but there were still a few non-library offices on the upper floors. There was a large basement area, where a lot of History's and Children's departments' "closed stacks" books were stored. The Children's department moved into the Book Stop space on one side of the first floor, while the other side had the film and video area, plus an information desk. Circulation was in the central lobby. Like many buildings of the 1920s, including Central Library, the second floor was the main floor of the Design Center, with high ceilings, elaborate décor, etc. History and Art had their public areas on that floor, along with rare books. Business and the Periodicals Room were on the third floor, while Science was on 4 and Social Science on 5. Literature and International Languages shared the sixth floor, with our closed stacks on the seventh. These floors were smaller than the ones below, because there was also a fairly good-sized auditorium on the sixth floor, which we used for order meetings and other library functions. Some of the Social Science collection was also on the ninth floor.

Leslie Nordby was in charge of the move. Once again, we had many committees and sub-committees, and we spent a lot of time counting shelves, counting catalog drawers, figuring out where various call numbers would be shelved. We started at

Children's librarians would often put on puppet shows to boost staff morale.
(Sheila Nash, Los Angeles Public Library Institutional Collection)

the bottom of the building and worked our way up, so Literature and Languages were last to be shelved. Of course nothing worked out exactly as planned, and we spent lots of time unpacking books, breaking down boxes, shifting, reshifting, and reshifting again and again. In fact, we never did get everything shelved in Literature—there simply was not enough room. Eventually some of our books went to the ninth floor and the basement, so we were scattered over four floors, and stack requests could take a LONG time! Doing the heavy work of moving pallets up and down the freight elevator was a company called Crest Movers, which tended to employ a lot of fairly shady characters as day laborers, so that made for an interesting experience as well.

Finally, we were ready to open in April 1989. I recall the opening words of Helene's theme song for this era (adapted from Cole Porter's "We Open in Venice") were, "We open on Spring Street, we've played Rio Vista. I'm tellin' ya, sista, lots of laughs in that show! We next got to clean up those grungy, scrungy volumes, then inventory, what a story, then we open again—where? On Spring Street!"

We had an automated catalog for the first time, put together with all those inventory cards, though of course it was very primitive by today's standards and had no indication of number of copies, ref. or circ., etc. I forgot to mention that there was also a rooftop restaurant, the Board Room, which was actually quite elegant (and not very well used, other than by library staff; it eventually closed while we were there). It even had a piano player who would play a lot of old (think 1930s and 1940s) standards. I just read that the Title Insurance and Trust building is reopening

Librarian Renny Day at the reference desk in the Spring Street Children's Department. (Renny Day & Bob Day, Los Angeles Public Library Institutional Collection)

as office space later this year—again with a a rooftop restaurant!

About the move back to Central I have less to say. That move was done by professional movers. But we did have to do a lot of calculating about which books would go to which shelves. I still have some of the figures I did, comparing how many shelves various call numbers and fiction letters had on Spring Street and how many they would have in the new building. The Spring Street library closed in June, and most of the staff went to branches for the summer. A small group (less than ten, I think) stayed behind to oversee the work of the movers and answer any questions they had. Once the books got shelved, they were all barcoded by clerks. The original plan was for all of us to move in several weeks before opening, during which time we would have orientations, training, be able to unpack and arrange our offices, etc. But it turned out that the builders (Tutor-Saliba) took longer than expected, and the certificate of occupancy didn't come through until about three days before the grand opening. In fact Tutor never did quite finish up—which is why, among other things, the desk lamps at the literature desk never had electric lights put in them!

The early nineties had been a very difficult time financially, and Central Library (and LAPL as a whole) lost many staff positions during those years on Spring Street. We often remarked that if the economy had been in that kind of shape at the time of the fire, the city might not have been so willing to rebuild Central and keep a staff of librarians who were doing some rather non-librarian jobs over a period of several years. And in 1993, the city budget was still in serious trouble; it would take

Bob Anderson is ready to assist patrons at the Spring Street Literature & Fiction reference desk.
(Cary Moore, Los Angeles Photographers Collection)

several more years before things started (at least for a while) to look better. I came across a song lyric that I wrote (inspired by Helene) that pretty much sums up this era:

June is moving time at Spring Street! We're leaving these overcrowded halls, where the air conditioning's shut off and the telephones all cut off and the patrons overdose in toilet stalls. June is moving time at Spring Street! The books'll go flying out the door. We'll reopen in October, but there's not a lot of hope for extra hours or free parking for the poor.... because we're broke! Broke, broke, broke! L.A.'s budget's up in smoke!

Left: Books and balloons greet guests on opening day of the Spring Street location. (James Ruebsamen, Los Angeles Herald Examiner Collection)

Below: Betty Gay Teoman, Wyman Jones, Library Commissioners Mary Lou Crockett and Martha Katsufrakis, and Mayor Tom Bradley get ready to open the doors of the temporary Central Library on Spring Street.

Staff member James Van Gerpen packs up computers for the moves from Spring Street to Central Library. (Sheila Nash, Los Angeles Public Library Institutional Collection)

Packed-up books at the Spring Street location, ready to make the journey back to Central Library. (Sheila Nash, Los Angeles Public Library Institutional Collection)

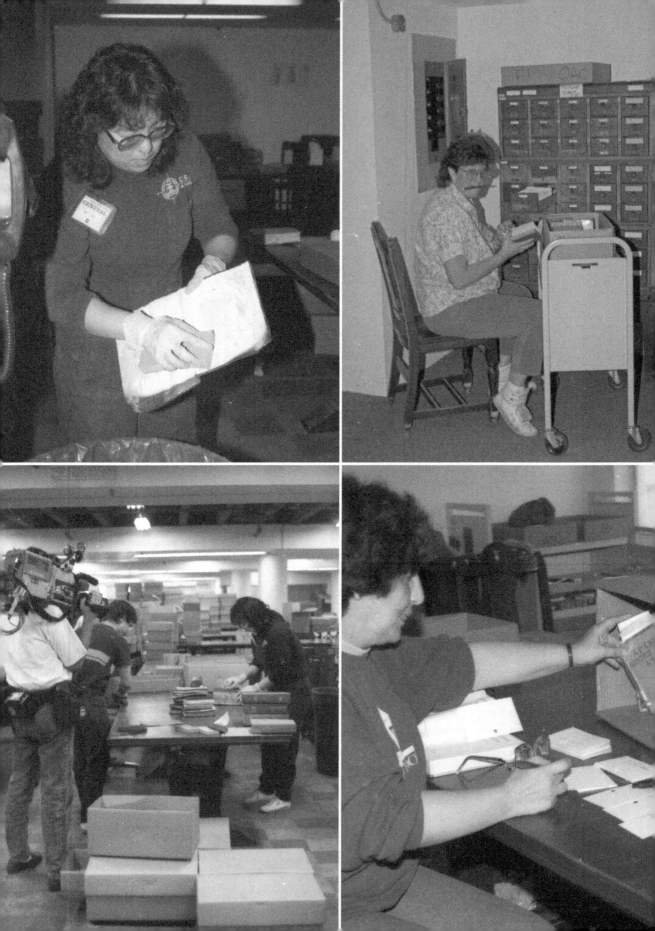

A DOCENT'S LIFE FOR ME

By DELORES MCKINNEY
Central Library Docent

I HAVE ALWAYS loved books. When I was five, I pleaded with my mother for books...Little Golden Books, about lambs and engines and whatever...and she helped me learn to read them. In junior high and high school, I was a library helper. (I learned to make change when a kind librarian taught me not to try to do mental math—subtracting the fine (35 cents) from the money given ($1). I always got lost somewhere between "borrowing" and "carrying" and felt stupid. She counseled, "Just start with the fine and then take out the money to get to the amount they gave you." Wow!! If you know the trick, it's so simple!

I love to read. It's my greatest pleasure in Life. But it's more...I love books! No Kindle or e-books for me. I love the feel, the weight, the smell, the act of holding a book, turning the pages, choosing the just-right bookmark when I start down a new path of adventure and learning. I love new books, so crisp and bright and pristine. There's even a "new book" smell! But older books are also wonderful, filled with memories of previous readers: dog ears (I gently unfold the corner), sometimes underlines or "corrections" or opinions, drips, wrinkles, frayed page edges...

One day, in the *Los Angeles Times*, a "volunteer opportunity" caught my eye. I had been looking for an appealing way to spend some free time and help out somewhere. "The Los Angeles Public Library is seeking volunteers to prepare books for the opening of the temporary location of Central Library," and a phone number. Books...Library...Perfect!

I called the phone number and was told to come to 433 South Spring Street

Volunteers clean and check the books against the card catalog to note "survivors" of the fire. Throughout the recovery process, the media showed constant interest in the progress. (Los Angeles Public Library Institutional Collection)

(parking provided). When I arrived, I was sent up to an upper floor of "The Annex," the building next to the library's future home. I walked into a huge open space, with people working at long tables. Scattered among the tables were several pallets, piled high with cardboard boxes. I was shown to an empty chair at a table and given my instructions. "Get a box from the pallet. Take out each book, inspect it for damage, wipe it down with this (provided) cloth. Take it to the card catalog (which had been moved to a nook of the warehouse-like space), find the catalog card, put it in the book so it's visible, and draw a small red (red pencil provided) circle on the title page, return it to the box. When all the box's books are done, put the box over there (point) and get a new box." (Next time you pull a book off Central's shelves, look at the title page. If there's a red circle, you have a survivor in your hands!) Oh, yes. One more detail. "If you don't find the book's catalog card, write the title, author, and Dewey number on a slip (small stack provided) and put it in the book."

I got the chance to work twice before the job was done. What fun!! Every box had surprises...delights. I never knew what the books would be: science, history, art, business, religion. Like Little Jack Horner, I could "stick in my thumb (and attached hand) and pull out a plum!" We volunteers often showed off our prizes to each other...and, of course, we had all been told to take anything published before 1850 or that looked unusual or valuable to one of the librarians supervising, for his/her decision. (The rare books collection grew fourfold, thanks to this book-by-book look at the accumulation of 100 years of book purchases.) We didn't know at the time but our "survey" had a second purpose: preparing the books for entry into LAPL's first computerized catalog! By today's standards, the computer was a Model-T but it was the beginning.

Now, the pallets were empty. Job finished. Well, maybe not... A couple of months later, "volunteers to help shelve books, to prepare for the opening of the temporary..." This time, I came with two friends. Again, we worked twice, putting those boxes of books onto the new shelving in the departments.

The term "back-breaking" was always just an expression until we started putting books up in Social Sciences on the Temp's 5th floor. Four boxes arrive. We shelved them, nice and neat. Six more boxes arrive. One will fit at the end of our previous work. The other five? Right in the middle of those nice neat rows... Move these books down three shelves. Put them in there. Four more boxes. Yes, you guessed it. Move those books again.

We worked hard and left exhausted but happy, leaving behind orderly rows of information, waiting for someone to pull one of them down and use the information to advance...or even change...their life.

Some months later, yet another "volunteer opportunity" appeared in the *Times*. This one said the Los Angeles Public Library Docents were recruiting volunteers for training to conduct tours of Central Library. There was a phone number, if you were interested. Interested? It took my breath away!

I called and an application was sent to me. I filled it out, mailed it back, and was asked to come in for an interview. I told no one (except my husband) that I had applied. I didn't want to be embarrassed if I was turned down. I had no degrees, no credentials...I was a waitress. I felt honored when my interview resulted in my being invited to training!

There were only four of us in that first class after the library re-opened on Spring Street. I still, 27 years later, look back on my 12-week training as one of the most amazing experiences of my life! I traded shifts with an amiable waiter at my job so I could have Wednesdays free. Each week, I drove

Over the years, Central's librarians had taken interested school groups and adult organizations on requested tours. Proposition 13, in 1978, drastically slashed funds to LAPL. Every budget had to be cut "to the bone." Central's director, Loyce Pleasants, and her assistant, Betty Gay, began to look into volunteers to take over tours. In 1980, the first library docent class graduated. Though docents are a common sight at museums, LAPL's docents are believed to be the first associated with a public library.

downtown (an experience in itself) to learn about a new set of treasures in another of Central's departments. No room here to catalog the wonders. They're all still there, available if sometimes unnoticed, overshadowed now by the overwhelming beauty of the restored Goodhue. There's a very substantial reason LAPL is always first or second in public library statistics...and it's not the art.

The Temp was a unique space for a library. It wasn't in a "good" part of downtown, Spring Street, on the edge of Skid Row. Designed by Los Angeles's premier architectural father/son team, John and Donald Parkinson in1928, the 11-story Title Insurance Building was an Art Deco delight in itself. Like nesting dolls, the library was a treasure within a treasure, spread over six public floors. The Children's Department perched to the left of the beautiful marble and bronze Lobby. The huge, largely open space of the 2nd floor (with historic elements still in place) was divided between Art/Recreation in the front and History/Genealogy in the back. In the northwest corner, the old Title Insurance vault, complete with foot-thick steel door and combination lock (just like in the movies!), was packed with Rare Books. Oh! And the pneumatic tube system that once rushed messages and important paperwork from one floor to another was still there...though I think its useful time was over.

The 3rd floor was smaller and stripped of the Art Deco detail by an earlier Design Center remodel, as were all the other upper floors. Business/Economics shared it with the Copy Center (which included the historic magazines and newspapers). Four was Science/Technology, Five was Social Sciences, and six was again divided between Literature/Fiction and International Languages (the once-

Exterior view of the temporary Central Library at 433 S Spring Street.
(Los Angeles Public Library Institutional Collection.

used term "foreign" having been banished).

We docents loved the library and tried—really hard!—to bring tours in, but we didn't have much luck. A few Boy Scout troops, a few ESL (English as a Second Language) tours from Downtown's Evans Adult School...that was pretty much the total of people wanting to see the Temp.

With so few tours and time on our hands, most docents chose a department to work in, helping with projects the librarians no longer had time for. There were docents cataloging menus, working with photos in History, playbills in Literature. A docent put together a scrapbook of clippings on the fire; another, a scrapbook of the 1984 Los Angeles Olympics. Both are invaluable resources now. My project was great fun, if not of great value. I worked at cataloging the doll collection in Children's, an informal accumulation over many years of ethnic dolls, illustrating national and/or regional costumes. They were brought back by vacationing librarians, for use in programs and talks, to help young people understand and develop a world view of their own.

Valuable or not, I loved the countless hours I spent with those little persons.

I learned a lot, using Central's resources to trace "doll marks," identify national costumes, and more. I helped settle those children's denizens into acid-free tissue and boxes, patting down hair, straightening limbs, easing wrinkles and creases in costumes. It would keep them safe...and ready for their next appearance. And we all marked time until The Big Day!

I considered myself a novice docent, not much experience, a true "newbie." So I was startled when I was asked to become the docent president in 1992. Whoa! I felt brand-new...I had never even been in a "club" since high school, let alone been the leader. But the core docents, the ones who had kept the organization going, promised to stand behind me and help...so I agreed.

A buzz was starting around the Temp. The new construction on the Goodhue had "topped out" with flags and a ceremony. We were going to move again...back... SOON! We recruited that spring and got a huge class, 30 or so people eager to learn and be a part of the next big step...the Goodhue! During the training, there was one wonderful day when Betty Gay, now Central's director, came to tell us about the progress. We gathered around a long table in History, many standing behind the seats, and listened while she described what was happening and then showed us samples of carpeting and upholstery...beautiful samples! She made it real...it was going to happen!

That summer, the library also began a campaign to issue the new library cards, in advance of the re-opening. No more little white paper cards! The card was now sturdy plastic, bar-coded, snazzy dark blue and orange. "Check It Out!" was printed boldly on it! Volunteers, many of them docents, sat at tables and took applications...around downtown, at events, at shopping malls, anywhere foot traffic brought people. I spent a hot day at the zoo, greeting and explaining and collecting applications.

We docents were invited for a "construction tour," led by City Architect Bill Holland. We donned hard hats at the 5th Street entrance and enjoyed an insider look at the work, with an insider to comment! My best memory? We climbed the north stairs, past the sphinxes under their protective canvas covers, and down the short hall to the rotunda. There were heavy plastic curtains closing off the entryway. We brushed them aside and stepped in... I can still remember the moment of entering that space. My first thought was that it was like a cathedral...elegant, late-afternoon shadowed, austere. The marvelous chandelier was on the floor in the center of the space but the Cornwell murals stood guard to protect it. Afterward, we walked down the second floor hall to an abrupt end and looked over into the gaping hole of the future atrium.

We knew that when we moved back to the Goodhue, we were not going to be able to use the tour we had learned at the Temp. We needed brand new ideas. So, five of us (the tour committee!) went on another visit to Goodhue, this time taking notes and drawing little maps and looking critically at what should, or should not,

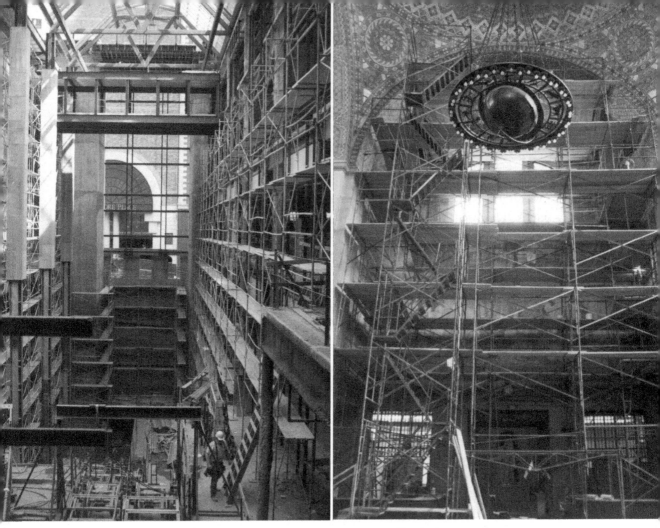

**Limited tours of the construction site were given to staff and volunteers.
Here are views of the atrium and rotunda under construction.
(Renny Day/Bob Day, Los Angeles Public Library Institutional Collection)**

be included in an hour. Our ideas were combined (and underwent a lot of debate) and we came up with the new tour, limited to the 1st and 2nd floors, since that's all we could see, the atrium still just a huge empty space.

A date was set! The Goodhue would re-open on October 3, 1993! The Temp closed in May so professional movers could prepare to transfer 120-plus years of accumulated knowledge from one location to another...seamlessly. Now the docents were (temporarily) homeless. We met at the Chinatown branch's community room; we met at a docent's home; we met in a too-small room at administration's headquarters, with people sitting on window sills and radiators (fortunately cold in August). The question of the hour...day...MONTH?! When would we have access to the Goodhue, to practice our new tour? Through that long summer, we were repeatedly given dates, only to have them cancelled. The construction wasn't finished...

FEELS LIKE HOME

Central Library docents wore a simple yellow ribbon to identify themselves on opening day. (Image courtesy of Delores McKinney)

The other hot question? What should we wear for the big event? A division of opinion: some wanted an official look, blazer with slacks or skirt; others, more maverick, wanted no dress code. (The docents had always worn simple business/casual clothes for tours.) We turned to our librarian advisor, Joan Bartel, to decide. Her answer? White shirts or blouses, black slacks or skirts, docent pin, and a bright yellow ribbon with "Los Angeles Public Library Opening Celebration...Docents...October 3, 1993," printed on it. Easy, comfy, good!

Finally!! A date for us to be in the Goodhue... to practice...even though it was October 2nd, Saturday before the Sunday opening. We met at 10 a.m. in one of the 5th Street meeting rooms, everyone glowing with excitement! As president, I started through a short list of reminders for the next day. It was maybe 10:20 when the loud speaker system announced: "All unauthorized persons must leave the building at once."

What?! We looked at each other...were we authorized? We thought we were, but... the question was settled a few minutes later when a person came to the room's door and said we had to leave. We all nodded agreement. The door closed. Drat! Foiled again!

We conspired... we couldn't go as a group but maybe, if we went singly or in twos... if asked, we'd say we're on our way out, as directed... maybe we could at least sneak a look around... Personally, I saw the now-pristine rotunda, chandelier restored to its rightful prominence, and the atrium, no longer a chasm but all decked out with escalators and terra cotta pillars and gleaming green floors, extending downward... And huge colorful chandeliers! Amazing! Enough...I fled before I could be evicted!

October 3rd dawned a perfect Los Angeles day—warm, but not too warm, sunny and bright, cool breezes wafting by. We docents met at 10 a.m., in our new docent office (Wahoo!!). We overflowed into the adjacent staff room. I brought plastic "champagne" glasses and (not plastic) champagne and sparkling apple juice and we all, in our black and white and yellow ribbons, joyously toasted a long and happy life for our beloved Central. Then we trooped down to lower level one in the

atrium for a group picture or two.

Now, it was time to go outside for the ceremonies, scheduled for 11 a.m. We squeezed out the north roor and settled among the large crowd already waiting, spread along both sides of 5th. It was only a few minutes until we heard the opening notes of the Trojan victory song...and the crimson and gold U.S.C. band began to flow down the Bunker Hill steps to the crowd's loud approval. After a few stirring pieces, when the music stilled, we could hear rippling applause and cheers coming toward us down 5th. A bright-polished 1931 fire engine slowly pulled into sight, carrying a boatload of important people, waving and smiling. They moved to a decorated platform and there were "remarks," most of them thankfully short. Then, Mayor Richard Riordan and City Librarian Elizabeth Martinez cut the ribbon across the north door (*When did that appear there?*) and declared the library open. The big bronze doors swung wide...and we all surged in!!

We had already decided that tours wouldn't be possible; the library would be too crowded. (We had no idea HOW crowded it would be, though!) Instead, docents were stationed around the library, at the doors, in the lobby and rotunda, in the departments, to answer questions and welcome people. The first couple of hours, there were SO many people...it was hard to even move. It was thrilling! After the

An enormous crowd showed up for the grand re-opening and 5th Street was closed off to accommodate the excited group. (Photo courtesy of Gary Leonard)

Huell Howser was one of many media personalities at the opening. He dedicated a full episode of his popular program *Visiting* to Central Library reopening. (Photo courtesy of Gary Leonard)

long drought of visitors at the Temp, we were now overflowing with celebrating Angelenos.

My "15 minutes of fame" (though it was actually more like "3 minutes") came when another docent told me, "Huell Howser is looking for you. He's in the rotunda." I threaded my way through the happy crowds and found him upstairs.

He was an amazing man...so comfortable to be with that you forgot the camera, and simply talked to this interested guy who asked questions... (That night...finally home, fed, and rested...my husband and I watched *Visiting* on KCET and I was delighted with my small part in his now-preserved record of our wonderful day! Best moment? Telling him that while the Goodhue was gorgeous...with its marble and murals and new art... What <u>really</u> mattered were the incomparable collections... that deep, rich, ever-nourishing well of information on every one of the <u>MILES</u> of shelves!)

As time passed, I was busy checking that everyone was in place, relieving people for a short rest or a "comfort break," filling in gaps. I hadn't left the library since the doors opened. It seemed the crowds had eased off, still a lot of people but not the crush of earlier. I was relieving someone in the rotunda, a little after

1 p.m. The docent came back...she'd been outside...and I found out why it seemed less crowded. The fire department had shut the building down and no one was allowed in until someone else left. The lines at each door, waiting to come in to see our beautiful library, stretched around the block. Los Angeles was here, in force, to welcome Central home!

What a day!!

We docents had an ultra-busy schedule of tours now that the Goodhue was back. It seemed everyone wanted to see our lovely library! We had two "walk-in" tours a day and sometimes as many as six other scheduled tours in October and into November. We had guessed that Monday (after the celebration) would be a normal day though, back to business. The first trial of our new tour came at 11 a.m., our first "walk-in." Kathy Tusquellas and I would see how it worked in practice. We had 45 people waiting! We divided them, did the tour, and arrived back in the lobby about noon...to find it simply awash with visitors! Our "Monday-to-Friday" business and working neighbors were here to welcome Central back! I started just walking up to people and asking, "Can I help you?"

For a month after that, we scheduled docents in the lobby for two hours around noon to simply answer questions and give directions, in addition to docents doing the tours. The library responded as well to its new-found popularity. There was one person issuing library cards that first Monday. The next day, there were four and still there were lines of patient patrons each day, waiting for their new orange and blue card.

"How do I get a Library card?"
"Where's the History Department?"
"I want a book about fashion."
"When's the next tour?"
"What hours are you open?"
"Where are the magazines?"
"I'm interested in genealogy."
"Do you have best sellers?"

The most frequent question?
"Where are the books?"

Our tour underwent a major change some days after the opening. I was in the History Department for the first time...the bottom of the atrium...and came out to ride the escalators to the first floor. I looked up...and caught my breath!! Those chandeliers of Thermon Statom...the ones that looked like children's art from the first or second floor...were magnificent from below!! We had to change our tour!! No tour should leave without that view...and, now, no tour does.

As the docents grew accustomed to their new venue, there were a few glitches. A docent came breathlessly into the office... "The Ivanhoe murals are gone! I took my tour to see them and they're gone!!" This was serious indeed! It took a visit to International Languages on the first floor to assure myself they were really still there... Then I realized what had happened. The docent was on the second floor, in Art/Recreation, where there's an identical "nook"...same shape, same size...that houses the sports collection...and has no murals, instead of the first floor. Not the

first...or the last...mistake made but, all in all, the docents did a yeoman's job of touring all our new...and old...admirers!

The people of Los Angeles had nearly lost one of their greatest treasures but it had been saved and had risen, phoenix-like...bigger, stronger...historic beauty preserved, new beauty added...and they embraced it with love.

Opening day crowd move through the atrium under Thermon Statom's impressive chandeliers. (Los Angeles Public Library Institutional Collection)

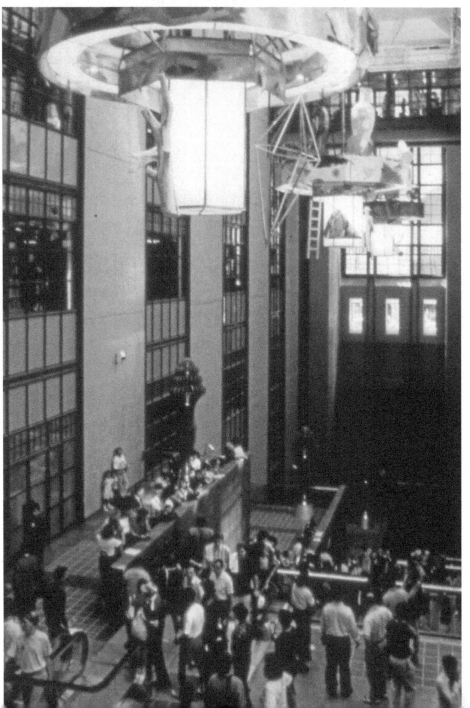

LOS ANGELES
CENTRAL LIBRARY PROJECT –
THE SHORT VERSION

By **BETTY GAY TEOMAN**
Central Library Director 1984-1998

CHRISTINA RICE'S REQUEST to write an essay about my experiences with the Central Library generated a swirl of memories. They are mostly about people at the library and those who helped us during the more than ten-year planning process to produce the rehabilitated and expanded Central Library which opened on October 3, 1993.

WORKING AT CENTRAL

Working on the Los Angeles Central Library project was the adventure of a lifetime for everyone involved. And, if you worked at 630 West Fifth Street in architect Bertram Goodhue's 1929 building in the 1970s and '80s, you were involved.

It had all the proper aspects of an adventure story: the lows of working in the shabby, crowded, unairconditioned Central Library; dreadful lows of the 1986 arson fires; highs of the post-fire community support for the library and the new Library Foundation; and the incredible highs of the two exuberant opening days; the May 22, 1989, temporary Spring Street Library and the October 3, 1993, Rehabilitated and Expanded Central Library. That last title is quite a mouthful, and we used it consistently to describe the project during the planning process.

It was often exhausting, discouraging, depressing, even frightening. These feelings were offset by the incredible grace, commitment and creativity of the people we worked with to revive this hugely important Los Angeles landmark—the Central

Portrait of Betty Gay Teoman during her tenure as Central Library Director.
(Los Angeles Public Library Institutional Collection)

Library and its historic building. And, blessedly, almost everyone involved somehow found a way to bring a sense of humor to lighten the enormous task. The regular children's puppet shows for staff who remained working on book inventory in the fire-damaged building immediately come to mind.

My close connection with Central Library started in May 1976, when I became Subject Department Manager for the Science, Technology & Patents Department. Living downtown and walking to work, I eagerly became part of the cadre of strongly committed people working in every nook and cranny of that remarkable building. The Goodhue building may have been on the National Register of Historic Places, but it was overcrowded with people and books, shabby, poorly maintained, with limited automation (possibly one computer per public reference desk), and with an outstanding collection of library materials packed tightly into stacks, everyone involved agreed had been a firetrap since the day it was built.

It was the public Central Library, administrative headquarters for the entire library system, and home for Technical Services for the system's books (let's use the generic term for everything we bought) and automation. Except for ARCO Towers and the California Club, the neighborhood was also shabby and the library's West Lawn park had long since been replaced by a parking lot.

BUILDING PLANNING

City librarians, library boards and city officials had been looking for solutions to the building's appalling conditions for years. These efforts focused on a new, much larger library. Whenever a prospect came along, administrative staff and anyone they could commandeer worked to explore and support the project. Soon after my arrival, I helped with the library's discussions with developer Charles Luckman and with architects Welton Beckett & Assoc. One proposal would replace Central Library with another, larger building on the same site. Another offered to build a new retail development in another downtown location, including a new library on that site. The Luckman plan generated enough community opposition to result in the 1978 founding of the Los Angeles Conservancy.

All this intense effort stopped cold when the 1978 passage of Proposition 13 made it clear the city had to confront other financial issues. It did not expect to have funds to build libraries for some considerable time. This was a very low period for the library which saw funding and staff cuts systemwide.

Gradually, behind-the-scenes discussions about Central Library resumed. City leaders, ARCO's CEO Lod Cook and developer Rob Maguire, saw the library as an important city asset right where it was. They had strong support from Community Redevelopment Agency (CRA) Director Ed Helfeld and the CRA board. In October 1982, the CRA formally presented a City Council committee with its proposal

to fund Central Library's rehabilitation and expansion. Months later, on April 26, 1983, the City Council approved CRA's financing concept and schedule.

Central Library now had a powerful advocate responsible for carrying the project forward. CRA knew the city planning process very well, but its staff usually reviewed developers' plans and did not manage city projects of this scope. The library board and administration still preferred a new library building and were skeptical of this approach. But now CRA had the money and the assignment. Central Library Director Loyce Pleasants strongly supported adding Library Project Liaison to my Assistant Central Library Director duties. It became my job to help expedite the CRA's new library project and report regularly to administrative staff to make sure all the library's interests were addressed and protected.

The CRA plan included funding for a new systemwide automation system and a library building consultant to develop the detailed building program for the architects. The library had solid information about the size of the current collection and staff but wanted professional guidance to plan for future needs. CRA would pay the bill, but City Librarian Wyman Jones would manage the consultant's building program effort. They couldn't agree to select a single candidate, so they combined two consulting firms into a team. Staff from throughout the library helped develop the building program which consultants Becker & Hayes, Robert H. Rohlf and the Omni Group published on April 30, 1984.

The library and CRA easily agreed to hire New York architects Hardy Holzman Pfeiffer Associates (HHPA), a firm with great credentials for successful work with historic buildings. In June 1983, CRA hired HHPA to assess the Goodhue building and produce concept drawings for the library. This was way ahead of having a detailed building program, but HHPA was looking at possible alternatives to expand the building and its services—details could follow.

These concept drawings were reviewed with the project's stakeholders to get their support. Among them were the Central Library Task Force of city department heads, Cultural Affairs Commission, Cultural Heritage Commission, AIA, Los Angeles Conservancy, California State Historic Preservation Office, CRA Board, Board of Library Commissioners, city Ccouncil staff and committees, and the full City Council. Mayor Tom Bradley was enthusiastic and strongly supportive. City Administrative Officer (CAO) Keith Comrie and his staff played a key role in the planning. Reviews by these and other agencies occurred at every stage along the way until final building plans were approved for bidding in October 1989. As liaison, and later the library's project manager, I was in almost daily contact with staff at the CAO, city attorney and CRA.

On August 20, 1985, City Council approved the project's EIR and all the appropriate legal documents to finalize the city's commitment to the project. HHPA was contracted for the next phase of the project design and the Central Library project was absolutely moving forward. Library board and staff began planning

**Betty Gay Teoman and Norman Pfieffer are pictured addressing the
Board of Library Commissioners about plans to renovate and expand Central Library.
(Los Angeles Public Library Institutional Collection)**

to move all services in the building to temporary quarters during construction. The schedule gave us more than 18 months to find them and make them ready for move-in.

FIRE

On April 29, 1986, arson fire closed Central Library. That Tuesday morning, architect Norman Pfeiffer was in my 3rd floor office reviewing plans for the 1st and 2nd floors of the Goodhue building. At 10:53 am, when the fire alarm rang, I told him false alarms happen often and we walked downstairs together, leaving everything there. It was late in the day, after 6pm, before we were able to return to check the condition of the building—and get Norman's briefcase and rental car keys.

As usual with alarms, I stayed in the 1st floor lobby until we evacuated the public from the building. When it became clear there really was a fire, I called the CAO's office from the security desk phone to notify them and then left. For awhile, Norman and I stayed near the fire department command center to answer any questions they had about the building. The stacks were confusing under the best circumstances and now they were filled with smoke, flames and water. It was a very long day. I later learned from fire department staff that they nearly lost the building.

Betty Gay Teoman and Norman Pfeiffer keep a safe distance while firefighters battle the Central Library blaze. The pair had been going over renovation plans when the fire broke out. (Evelyn Greenburg, Los Angeles Public Library Institutional Collection)

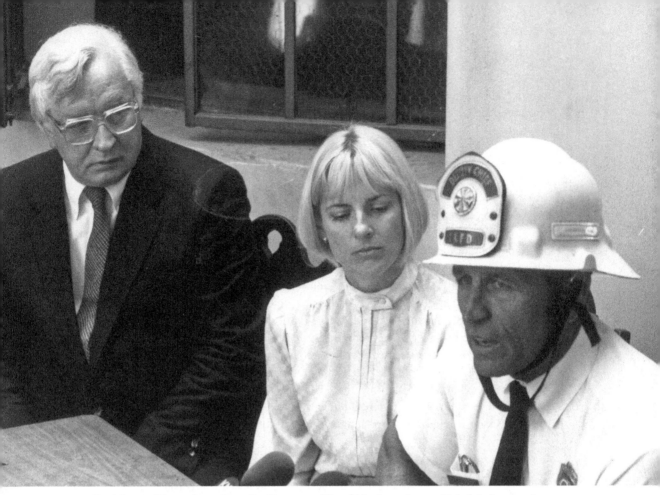

City Librarian Wyman Jones, Betty Gay Teoman, and Donald Anthony, deputy chief of the Los Angeles Fire Department are pictured during a press conference following the devastating Central Library fire. (Los Angeles Public Library Institutional Collection)

Being able to break through the roof to put water on the burning closed stacks finally worked.

Three years of public meetings and newspaper articles about this huge public project had not captured the general public's attention. The fire, however, created a groundswell of Los Angeles community support. That first volunteer crew included 1,700 people of all ages who came downtown from all over the county to staff recovery teams, which worked 24-hours-a-day. The CAO immediately found us the salvage company, Document Reprocessors, and City Council urgently approved the required funds. Community volunteers removed books from the wet, dark building and packed them for freezer storage. By Saturday morning, the last pallets of wet books were lined up along Hope Street waiting to be picked up for delivery to freezer storage in a produce district warehouse.

And planning for the Central Library project became even more complicated. It also became very personal for everyone who had worked in the damaged building, all of whom were immediately given new assignments, mostly in new

locations. Administration and Technical Services had to be immediately reactivated to support the system. Locating and planning temporary Central Library facilities then became the system's highest priorities. Day-to-day staffing and book recovery efforts had to be managed. On September 3, 1986, a second arson fire in the Art & Music wing caused further damage to the collections and to everyone's emotions and morale.

It wasn't initially planned that way, but because continuity was important, I had become the library's project manager and, after February 1984, also its Central Library director. It was only possible because staff in the Central Library director's office and the subject department managers carried a very heavy workload. They were bright, hard-working, able to work very independently and knew when to communicate and when to ask for help. I was responsible for Central Library's operations, but they managed them.

After the fire, we had a lot of new tasks. The 395,000 burned books were gone, but which ones? The 750,000 wet books were frozen and staff questioned whether they would ever return. Books remaining in the library needed

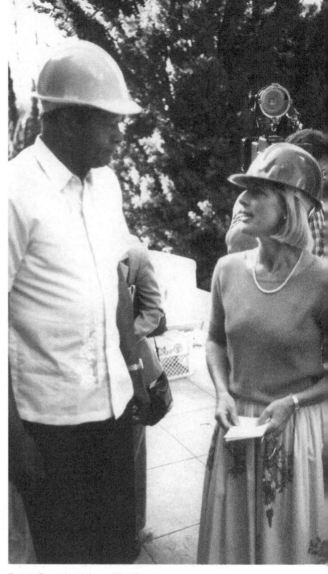

Betty Gay takes Mayor Tom Bradley on a tour of Central Library to assess the damage following the fire. (Los Angeles Public Library Institutional Collection)

to be inventoried to begin a new catalog. The old card catalog sat in the rotunda, untouched by the fire, but an artifact. We had to find and outfit a temporary Central Library, but before we could open it, we had to plan and activate a book processing center to complete recovery of the salvaged frozen books. The work was hugely complex, and Joan Bartel, Pat Kiefer, Lori Aron and Ruby Turner, in particular, were amazing. Every one of the subject department managers should be added to that list along with managers and staff from Technical Services and Administrative offices. The post-fire period demanded great resourcefulness from everyone.

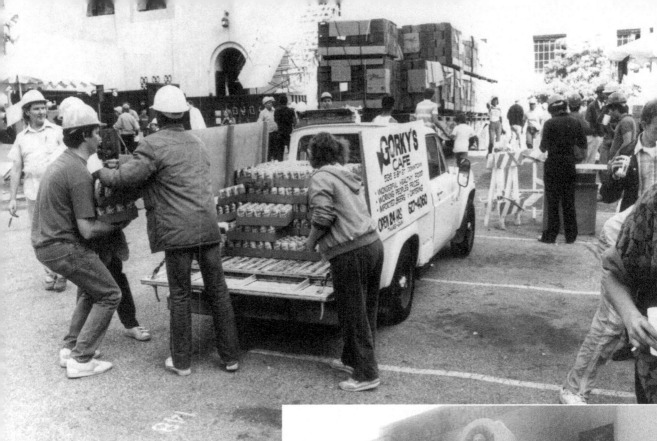

Above: Catering arrives from a local restaurant for the countless volunteers and staff working to pack out Central Library's remaining collections. (Los Angeles Public Library Institutional Collection)

Right: View of the impressive slide used to transport debris from the upper floors of Central Library to a dumpster. (Carolyn Kozo Cole, Los Angeles Public Library Institutional Collection.)

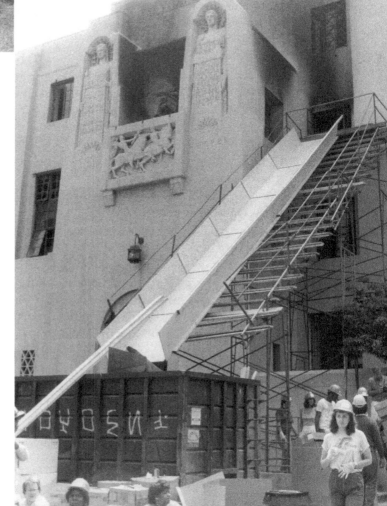

BUDGET

During the lengthy planning period, the project budget predictably increased substantially. The financing plan was very complex, with a substantial amount coming from the sale of air rights and tax increment bonds issued by the CRA. CRA proposed a sale-leaseback of the historic building as the third funding source. It added many legal and planning steps to the process. The city's planning team would hold its collective breath at the end of each architectural design stage when HHPA presented an updated construction cost estimate.

In November 1987, the City Council approved a $152.4 million Central Library project budget. By April 1993, it approved the final $213.9 million budget. Each time costs increased, the planning team and CAO thoroughly documented the dollars required. And the City Council approved the funds and reinforced its support for the library. This budget does not include the cost of fire recovery efforts and temporary quarters for library departments. The city's commitment was huge.

Early in the budget process, the city proposed to delete the auditorium from the project as a cost savings. We struggled mightily with that key issue and found an advocate in Councilman Joel Wachs. He introduced a motion on the council floor to add the auditorium back to the budget, stating he was confident a donor would be found in the future to pay for it. It was critical to the project, and he was right—the Mark Taper Foundation donated $1 million to name the auditorium.

Barney the Dinosaur delights children in the Mark Taper Auditorium.
The space was almost a budgetary causality until the Mark Taper Foundation stepped in.
(Los Angeles Public Library Institutional ollection)

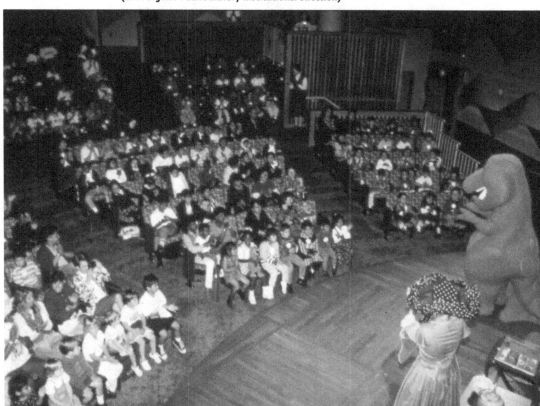

ART PROJECTS

The CRA intended the Central Library design to faithfully follow the Secretary of the Interior's Standards for Rehabilitation. It saw the substantial cost of rehabilitation of the Goodhue building as the Central Library project's contribution to art. Then, in 1988, the Cultural Affairs Commission required a percentage of the project budget be dedicated to new art projects. Architect Norman Pfeiffer proposed that functional elements of the building's new wing be designed and produced by artists: elevators, atrium chandeliers and standing light fixtures, children's courtyard fencing and fountain. On the West Lawn, fountains became additional art projects. Selection of artists began in December 1988. The art projects require their own article—it's a great story.

Left: Public art projects for the expanded Central Library included Therman Statom's trio of chandeliers symbolizing the natural, technological and metaphysical spheres of existence and Ann Preston's *Illumination* **light fixtures, both located in the atrium of the Bradley Wing. Below: Renee Petropoulos tied in motifs from** *Rotunda in her Seven Centers* **ceiling mural shown here being installed in the main lobby. (Los Angeles Public Library Institutional Collection)**

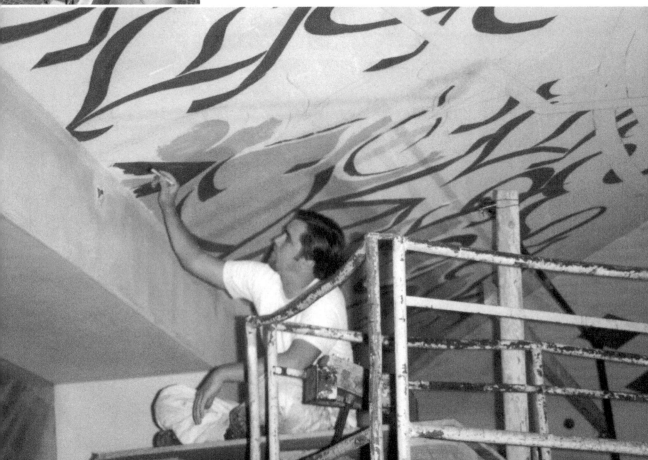

LAST THOUGHTS

My title promises "the short version," and this actually is. Among the issues it doesn't address are the support we received from the Getty Conservation Institute, the Save the Books campaign and ARCO fundraising staff, and the huge complications of moving the library into Spring Street and then back home to West Fifth Street.

The May 22, 1989, opening of the Spring Street Central Library was a land-mark day. The city had been without a Central Library for nearly three years. That time was hard on the community and particularly hard on us. We kept thinking we should make it happen sooner—for the public and for the staff. More than 3,700 people attended the day-long open house on the Saturday before the official open-ing. Seeing people, especially families, using the library again was a huge milestone for everybody and a great pleasure.

The October 3, 1993, Fifth Street Re-opening was most memorable for the huge enthusiastic public in attendance—who didn't appear to care on that day that signs were missing throughout most of the building. It took many months after opening day to complete work on what was a bit more than a punch list. And of course, few things worked quite like they were supposed to, but we learned quickly.

Working with the HHPA team led by Norman Pfeiffer and Steve Johnson for nearly ten years was a great pleasure and steep learning curve. No matter what hap-pened in the lengthy review, planning and construction process, they never got ex-cited. They just went to work to find a way to resolve any issue that was raised. My job was focused on function—to make sure the building HHPA designed worked well as a library. I channeled to them the plans, decisions and best thinking of all of us in the library. Then library staff and I checked the work each time HHPA revised the plans to make sure they included everything we asked for—and that what we asked for worked well on the plans.

After one of the early public design reviews, I left the meeting deflated by the harsh reception for the Central Library's latest design. Norman told me, "Don't worry, we'll change it and make it look great." Design was his responsibility and he and HHPA were very good at it. Our roles were clear, and I didn't worry about de-sign again.

It gives me pleasure to see HHPA's subtle design signatures in the building: former history room ceiling and rotunda mural motifs subtly repeated in the new children's room carpet; Goodhue building ceiling patterns in the East Wing car-pets; and the Central Library building woven into the Mark Taper Auditorium's upholstered seats. They were respectful of Goodhue's work and carried its themes throughout the building in a thoughtful, clever and sometimes whimsical fashion.

The CRA proposed a Central Library project which was a public-private part-nership. Both sectors rose to the occasion. It showed exactly what the City of Los Angeles, its businesses and its community can do when they do their best. Working

on this project was exhausting and exhilarating. I wouldn't give anything for having had the opportunity to be part of the enormous team which built the Rehabilitated and Expanded Central Library.

Crowds wait to get inside Central Library on opening day. (Photo Courtesy of Gary Leonard)

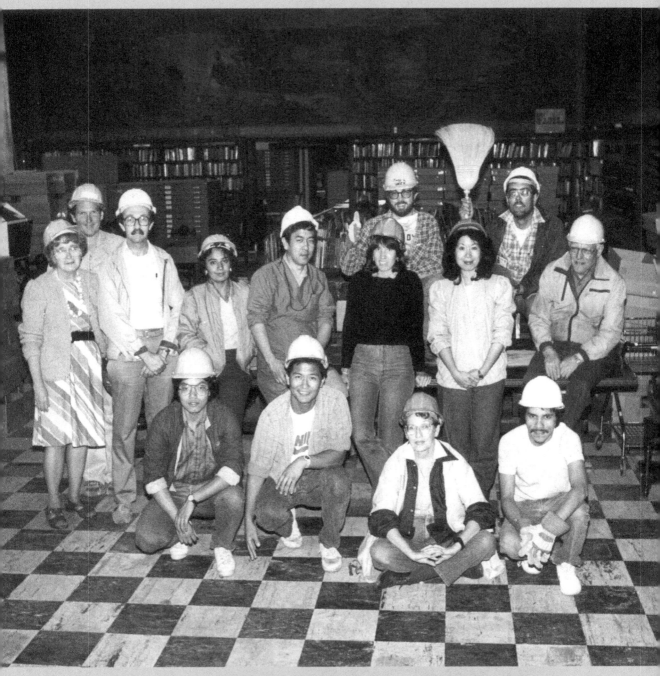

Central Library clean-up crew. Standing from left to right: Mary Pratt, Tom Owen, Michael Kirley, Gloria Ortega, Ted Itagaki, Linda Fink, Glen Creason, Betty Yan, Frank Louck, and Pat Paternoster. Kneeling/seated from left to right: Robert Kwong, Robert Lee, Bettye Ellison, Jose Paiz. (Photo courtesy of Glen Creason)

CENTRAL REOPENS

By GLEN CREASON
Map Librarian, History & Genealogy Department

"It's a thing to see when a boy comes home."
—John Steinbeck, *The Grapes of Wrath*

THE DAY MY own dear Central Library reopened I got my name in the *L.A. Times* which elicited ragging from pals around the city. "As soon as I crossed the threshold I got down on my knees and kissed the ground," it said in gushing prose, but looking back from my current vantage point that seems totally appropriate. Years of wandering in the desert were over and everything in front of me was brand new and full of hope. Kissing the floor in any public library may not seem like a good idea now but on that day the hallowed ground was antiseptic in more ways than one. I remember it well. *Chunking* is how psychologists describe that phenomena of the mental collecting of big picture memories of life passages. The brain manages to organize these recollections into categories that when lumped together seem to pass more and more quickly as the old planet spins us toward old age. It is the one LA freeway that is always moving briskly. While the last 25 years seem like weeks when I recall that sweet day I made my return to dear dirty Central Library, the previous 8 years to that wonderful day seemed like the biblical forty years. In my four decade career, the reopening is at the top of my very best days at Goodhue's masterpiece. I even have an old, wrinkly balloon stamped for the gala event that I keep for some reason and a cassette of celebratory songs I made just for the occasion. One of the songs was "Wellington's Victory March" by Beethoven which fit the mood perfectly.

Finally, there was a conclusion to a molasses slow crawl to becoming a real

major library again following the fire of 1986. The great day had arrived with plenty of "fuss and feathers," including lots of ink and air time. It was October 3, 1993, and we had just a couple of days before the big show to prepare for the greatest outpouring of library love in LA history. I was so excited I showed up *on time* with my nine-year-old daughter and walked past already-gathering giddy crowds to enter the building on the sweet Maguire Gardens side (once known as the Flower Street door). The long-suffering staff were euphoric, like kids let into Disneyland early, and we were all being treated to a genuine hot, deluxe breakfast by the Biltmore Hotel, just to add a little hollandaise to the fabulous feast of the senses on that memorable day. The first thing I saw was a homeless guy briskly walking away from the buffet table with a face like the cat who ate the canary. His plate was piled with bacon, scrambled eggs, actual French croissants and he was balancing a glass of fresh-squeezed OJ in his right hand. It was that kind of day for everybody. Party time in downtown! Imagine the Super Bowl, the Oscars, the World Series and the NBA championships taking place at 630 W. 5th street. I saw old library friends smiling smiles you could not have wiped off their faces if the devil himself had tried.

LAPL is represented at the 1992 Rose Parade. (Los Angeles Public Library Institutional Collection)

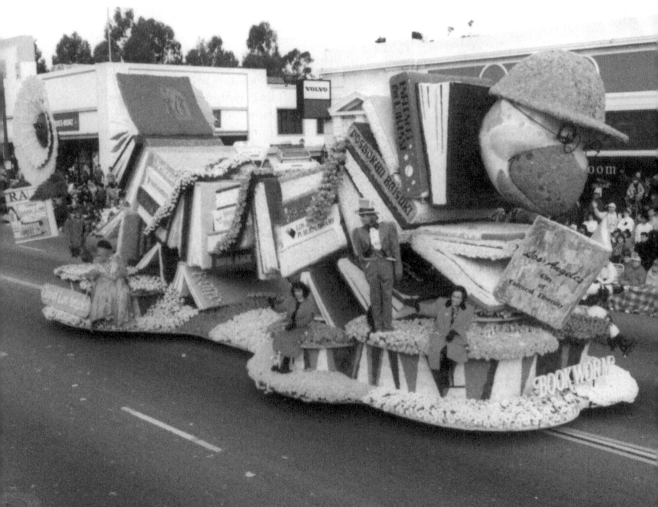

We had come home, minus a few dear ones but pretty intact considering the span of years and the plagues that had swept through our ranks in our time away. Staff were shaking hands with admin and hugging the formerly feared Betty Gay Teoman. It was just THE place to be in LA on that sunny Sunday and Huell Howser was there with Luis and cameras were clicking everywhere. The place just shone and everything was new and mostly working. The interior had that new library smell and when they threw open the brass doors at 10 am, it was wall-to-wall proud and happy Angelenos rushing into the ballyhooed gem of downtown. I could hardly stand still and joined the surging masses up and down the "grand canyon of books" even forcing myself and kid into a frame or two of the *Visiting* episode Huell was creating. It really was like Main Street in Disneyland on a summer day even if it was the fall. Central Library was at the center of the solar system, or so it seemed. A couple of months later we even had a float in the Rose Parade!

Central was in my blood going back to the 1930's when my mom used to walk over from Los Angeles Polytechnic High School on Washington Boulevard (where Trade Tech now sits) to do her homework before returning home to the family

Open at last! Two youngsters race into Central Library as Mayor Richard Riordan welcomes guests, including Council Member Rita Walters. (Photo courtesy of Gary Leonard)

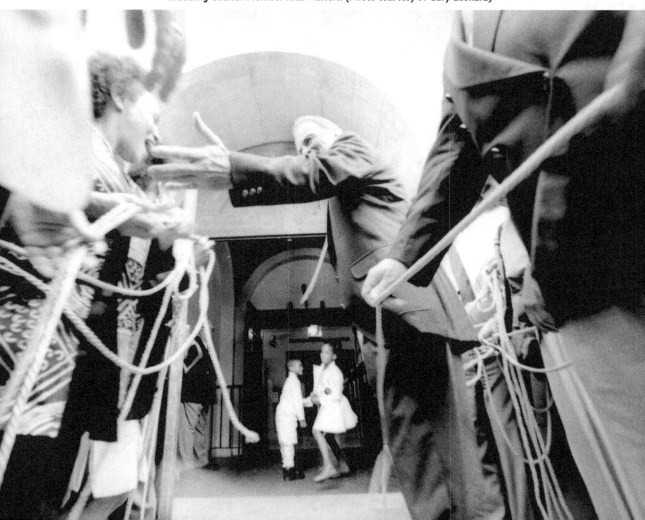

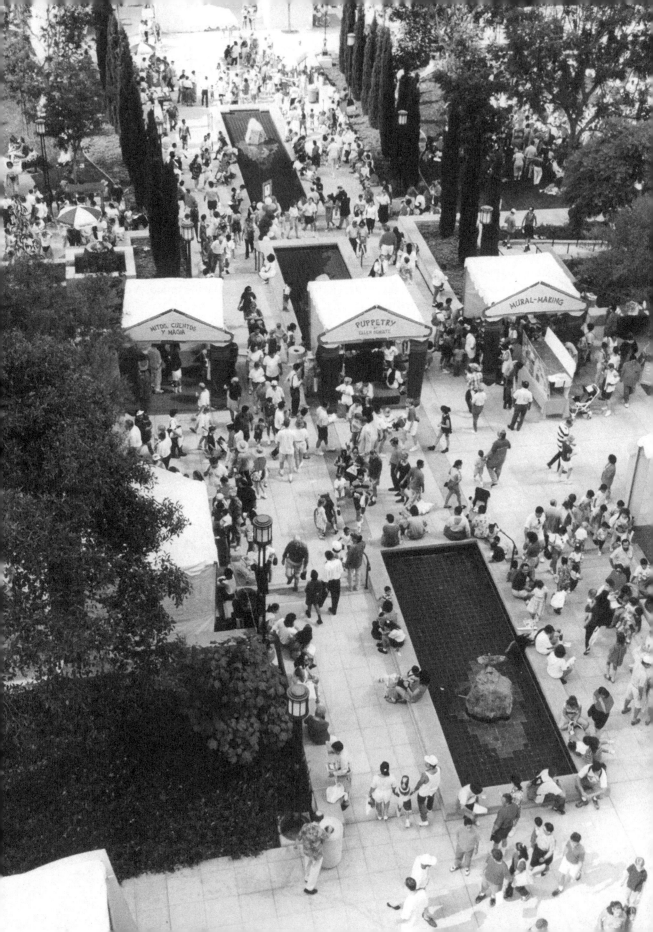

home on Bond Street (near the Convention Center). She loved the quiet dignity of the place and was overjoyed when I announced I would be joining the History Department where she often studied. That same grand reading room where she used to study with the tall lamps, hardwood tables, acorn motif chairs and murals on the walls that were bathed by soft light from the tall windows facing Hope Street. It was a room rich in LA lore, every inch well-worn but full of stories. When I actually began working in the History Department in November of 1979, I found out some other stuff about the beautiful and stately library. The tall windows could only be opened with poles so long and heavy that an Olympic pole-vaulter would be hard pressed to make the crusty vents unlock. One man, Ted Itagaki, could pop them open without fail but then someone had to shut them at day's end. It got very hot in all of the reading rooms and icy cold in spots during our short winters. There was a huge grate outside the department that belched heat twelve months a year which made summers hotter than hell in long underwear. The dumb-waiter that connected the department to the periodicals pool, a couple of tiers above us smelled like burnt cork and was not terribly reliable. There was an unpredictable stacks elevator that looked like it was from a science fiction novel that once imprisoned me for an hour after the Laker parade of 1980. We requested materials in good old-fashioned lamson pneumatic tubes like a department store, and they worked most of the time, but hopeful patrons would wait for a good long while as the Magazine Pool was mostly Miss Williams and a helper (Bob Colwell or Cary Moore). This besieged pair basically had one of the biggest periodical collections in the U.S. around them and every department in the building shooting the pool tubes full of requests for mostly heavy hard-copy magazines. The wait sometimes exceeded an hour but they worked hard up there. There were quaint balconies off the California Room and Map Room at opposite ends of the department but the doors were wired shut because dishonest researchers (see movie studios) used to toss reference books down to partners in crime, sometimes using fishing nets. When it got hot, is was miserable inside the old "masterpiece" and the few fans, now encrusted in greasy dust were not turned on because the electrical system was not equipped to power such demands. After all, in the stacks they had to use low watt bulbs so as to not blow out the entire building. The dim lights and very low clearance (less than my height) of these tiers made navigation dicey but interesting in a kind of creepy way. There is lots more about the shortcomings of the building and parking and security and the unique sights and smells but when you worked at Central you grew to love the old dear. It was a rare privilege to be part of the great library even if there were plenty of

Aerial view of the Maguire Gardens on opening day. The original West Lawn gardens had been demolished for a staff parking lot in 1968, so the Central Library renovation included a reimagined version with a subterranean parking garage. Developer Robert Maguire hired landscape architects Lawrence Halprin and Douglas and Regula Campbell to design a new interpretation. The pools leading up the steps contain sculpture by Jud Fine, with additional fountains designed by Mineo Mizuno and Laddie John Dill. (Los Angeles Public Library Institutional Collection)

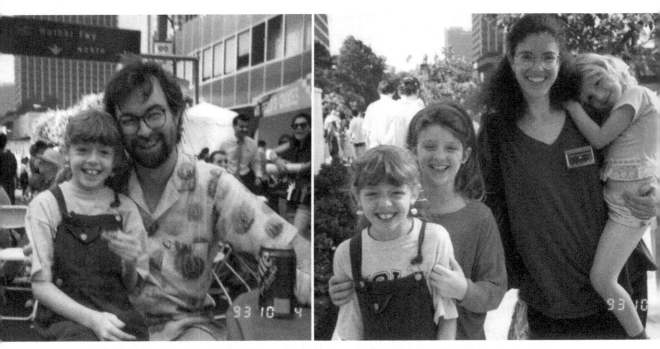

Left: Glen Creason and his daughter Katya celebrate the re-opening of Central Library on a closed-off 5th Street. (Photo courtesy of Glen Creason) • Right: Katya Creason (far left) and Teri Markson, Children's librarian from the West Los Angeles branch with her two daughters, Sephora and Hannah Matzner celebrate Central's reopening. (Photo courtesy of Glen Creason)

blemishes on the venerable building.

Preservationists would tell you that Central was a historical landmark and a bone fide treasure house but it was a lousy building for storing materials or providing creature comforts. Everybody knew the place was a tinderbox and that we were all living on borrowed disaster time but it was so much fun working there that we all overlooked impending doom because there was normally someone standing in front of us asking a question.

One of the most painful aspects of the library fire was the evaporation of the roles we had in the civilized side of Los Angeles. Central Library offered hope and encouragement to those who had little in society and a rich bounty for everyone who looked for enlightenment. Before the internet, before cell phones and before the grip of the Me Generation took hold, we were heroes with the keys to the treasure house that, despite our modest remuneration, made the job a joy. After the fire we were just in the way and sad creatures who were allowed to continue despite having nothing important to contribute except endurance and dedication. We had no patrons to tell us how great we were, we had no books to refresh our own hearts and the dismal, dirty surroundings just dragged us further down into the pit of depression. The dream of a new and better Central Library seemed far away, like

FEELS LIKE HOME

standing at the foot of Mt. Everest and looking up.

After the fire, the staff was gone on the LAPL winds and I ended up at the West LA branch while others spread across the landscape, including the infamous Rio Vista warehouse over off Soto Street. After happy years at WLA, I was forced to return to the miseries of the Processing Center next door to our temporary home on Spring Street in 1989. Even though we were thrilled to be reunited with our dear old book friends, 433 Spring Street was even less suitable as a library than the

Genealogy Librarian Michael Kirley was one of many staff members to sign the cornerstone beam for what would become the Tom Bradley Wing of Central Library. (Los Angeles Public Library Institutional Collection)

pre-fire Central. Besides introducing us to the computer as reference tool, our time on Spring showed the seedy side of libraries in the inner-city with an exclamation point. The plan was to reclaim Spring to its former glory when the Stock Exchange and Theater Center blended commerce and culture but it was mostly drugs and depravity that held grip on those blocks. We traveled in packs on gritty Broadway and learned to walk long distances to find lunch or relief from the mean streets. Basically, we were in a holding pattern until we could get back to the real Central. When the library closed Spring Street to begin the move back home, I ended up over at the good old Rio Vista warehouse for a project of transferring the tattered historic photo collection from the *Los Angeles Herald Examiner* into archival envelopes and boxes. We paced ourselves but finished a few months ahead of schedule, whereupon I was placed once again at a branch, this time at summertime Granada Hills where I discovered a great staff and San Fernando Valley heat.

The words in the morning papers and the stories on television and radio could not touch the pure joy of coming home where we belonged. Most librarians I have known are dedicated to service to their fellow man. It is not a job one takes on to gain wealth or glory but the rewards are great when looking at the big cultural picture. Beyond our sarcastic, dark humor, the humorous patron nicknames and the complaints about the craziness that exists in these public spaces, there is something like genuine love. Standing at the top of the Bradley Wing and looking down is all about that affection and satisfaction. Soaking up the library vibe in the rotunda or strolling through the Children's Department is like putting on the mantle of our profession. Being even a little cog in the big wheel of Central gave us pride in our work for building this magnificent collection and offering service to every bright-eyed kid, every eager immigrant, every homeless wreck seeking a little solace and a morsel of humanity.

What makes library work so fulfilling is the knowledge that you are handing out joy and hope and healing in a hard and not terribly caring world. Over the years we have given confidence, dignity and self-reliance without charge to a very complicated human mosaic. We soften the sharp edges, strum the heart strings and give people a reason to join together for improvement of the human race. "Love that conquers hate. Peace that rises triumphant over war. And justice that proves more powerful than greed." All of this we offer in this funny building with the pyramid on top if you just know where to look. Coming home for us meant coming home to those ideals and holding up the light of learning, handing over the key to the treasure room back to the people. It was our chance to be heroes again.

Staffers Sheila and Felicia busy organizing the Herald Examiner Collection at the Rio Vista warehouse. (Carolyn Kozo Cole, Los Angeles Public Library Institutional Collection)

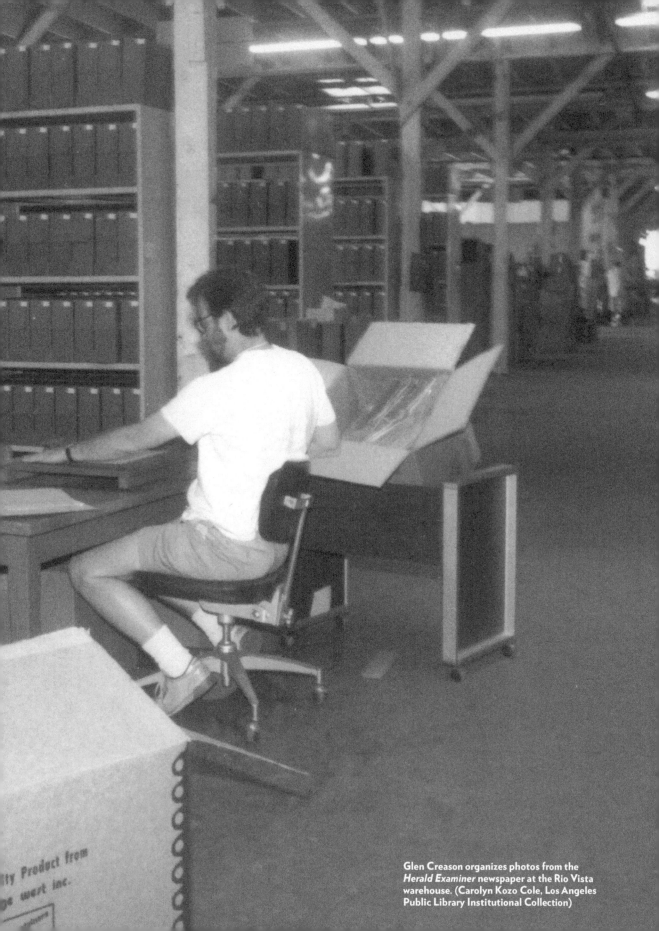

Glen Creason organizes photos from the *Herald Examiner* newspaper at the Rio Vista warehouse. (Carolyn Kozo Cole, Los Angeles Public Library Institutional Collection)

The new Central Library lobby featuring a ceiling mural by artist Renee Petropolis.
(Foaad Farah, Los Angeles Public Library Institutional Collection)

THE EARLY DAYS AT "NEW CENTRAL"

By BOB ANDERSON

I THINK I CAN SAY with certainty that the entire Central Library staff was happy and excited to be moving back to 630 W. Fifth in October of 1993. The temporary Central on Spring Street had enabled us to make our collections and services available to the public for the previous four years, but it had always been a stopgap until the "new" building was ready. In those first weeks, we were trying to get our work areas organized and get ourselves oriented between our shifts on reference desks, since we'd only been allowed into the building a few days before the grand opening. The plan had been to spend at least a couple of weeks setting up, but delays in getting the occupancy permit had scuttled that option. What we encountered in those early days was a library space that was vastly superior to what we'd had before, though it did have its own set of problems and peculiarities.

It soon became clear that we really had two buildings connected to one another—the Goodhue original and the Bradley Wing. Most of the collections and much of the reference staff were now housed in the new addition. It was wonderful to have all the extra space, plus working air conditioning. Old Central had no air conditioning, and what we had on Spring Street had become increasingly problematic in the last year or two that we were there. It did take quite a while for the temperatures to be properly regulated. In those early days, some floors would sometimes be too warm while others were too cold. We now had a much larger percentage of the circulating collection on open shelves, but those big reading rooms made it more difficult to assist patrons in areas far from the reference desks. Our workrooms were also much larger than what we'd had before—and there were a lot of empty cubicles, because budget cuts in the previous few years had reduced the staff to a much smaller number than planned for. In the closed stacks area, we experienced compact shelving, both manual and electric, for the first time.

As can be expected in a new building, there were some problems that became apparent pretty quickly. Leaks in the roof on rainy days were discovered fairly early on—both in the atrium and on the upper floors. There were no major disasters, but we did have to use plastic sheeting from time to time in some areas, and each winter the maintenance crew would repair things as best they could. It took quite a number of years before some money became available to completely redo the roof. Another early problem was the lighting over the reference desks.

Left: View of Therman Statom's glass chandeliers which received an initial mixed reaction, but have grown popular in the passing years. (Los Angeles Public Library Institutional Collection)
Below: Mickey and Minnie Mouse enjoying the atrium of the newly expanded Central Library. (Los Angeles Public Library Institutional Collection.

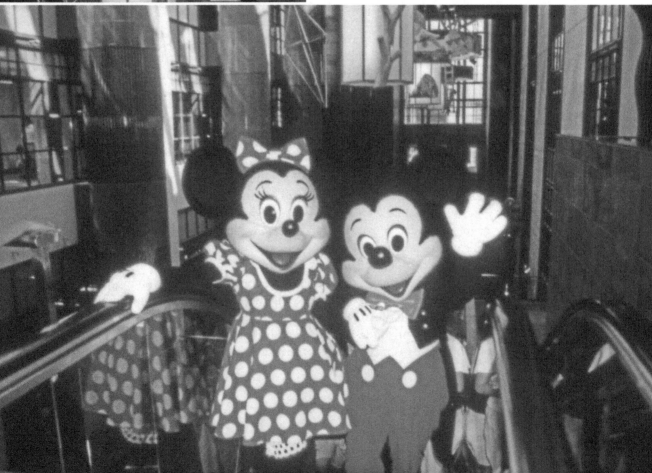

For some reason, the lights installed there were not particularly bright, while lights in other parts of the reading rooms were much brighter. It took quite a while to fix this, because it was not just a matter of putting in brighter fluorescent tubes; the light fixtures themselves had to be completely replaced. When this finally happened, we had been in semi-darkness for so long that I remember feeling like I was "on stage" at our suddenly brightly illuminated reference counter!

Another thing I remember from early days working in the Bradley Wing is the initial response to the three Therman Statom chandeliers in the atrium. To me and a number of others, they seemed almost garishly over-the-top at first, and we had quite a few negative comments (along with some positive ones) from patrons. But over time I got used to them and became rather fond of them, and most people who experience them today seem to enjoy them. So I guess Mr. Statom was slightly ahead of his time in designing this project—though it's also possible that the colors are no longer as bright as they were initially.

As for the Goodhue portion of the library, going into those rooms was a strange experience for those of us who had worked there pre-fire. The rotunda and the old reading rooms on the second floor were still there, but they were very

View of the Teen'Scape department. This space housed the Music department at the time of the 1993 opening, but adjustments to the Goodhue building have remained a work in progress. (Los Angeles Public Library Institutional Collection)

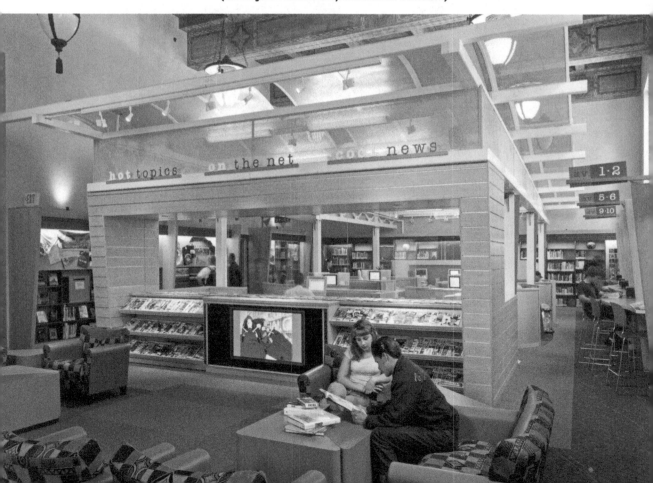

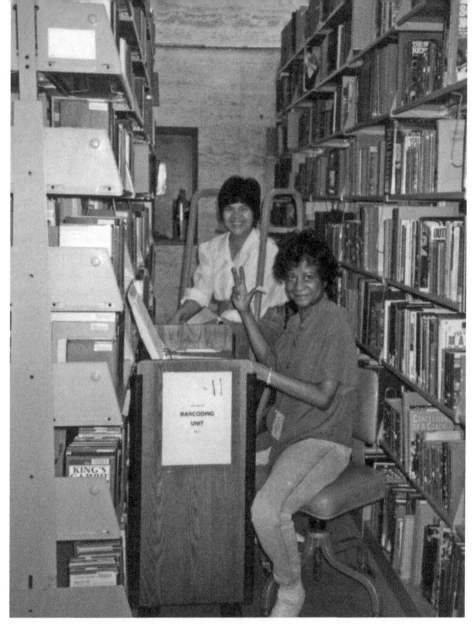

Staff barcode books in preparation for an automated cataloging system.
(Sheila Nash, Los Angeles Public Library Institutional Collection)

different from the dusty, stiflingly hot spaces we'd worked in—or from the fire- and smoke-damaged wreck we'd left behind in 1987. The enormous card catalog and the general information desk were gone from the rotunda, and it often seemed quiet and lonely when I passed through it. The former History Department was now beautifully repurposed as the Children's Literature Department, and the old Social Science and Literature rooms were also part of the children's space. The former fiction room now housed the music collection; some years later it would be turned into Teen'Scape. And the Science Department room, which had received the most

damage in the fire thanks to all the burning microfilm in the Patents Collection, was now the Popular Library and Large Type collection. Eventually it would be turned into the Getty Gallery, and Popular Library would be relocated to the first floor while Large Type would go to Literature. Some of the eastern annex of the original building had been demolished to make way for the new wing, but the old Children's and Art rooms were still there, now attached to the new International Languages and Arts and Recreation departments respectively. By contrast with the new spaces next to them, they both looked much smaller than I remembered them.

The administrative floor was now called the fourth floor rather than the third, because there was a new third floor below it that contained Rare Books, the Literature Department workroom, and a "conference center" room. That area had previously been the very crowded top level (seventh tier) of the closed stacks, housing most of the periodicals for History, Literature, Business, Science, and Social Science, plus many older Science Department books as well. The fire had been at its worst in that area, and almost everything had been either destroyed or damaged. The new rooms and corridors there were now almost completely unrecognizable. The Goodhue building basement, which had been a large collection of closed stacks in spaces with colorful names like Baronial Hall, Toad Hall, and Rat Alley, was now offices for the Catalog Department (previously on the administrative floor) and Technical Services (previously in the Anderson Street building).

The entire Central Library collection had been barcoded by staff after being shelved in its new home during the summer of 1993. At that point, only a couple of branch collections had been barcoded as pilot projects, and their holdings had begun to show up in the online catalog; as I recall, Mar Vista was the first of these. For Central Library's collection, each item in the catalog had two "smart" barcodes specific to that item (one reference, one circulating), and all additional copies beyond this were barcoded with "dumb" or generic barcodes. On opening day, and for some time thereafter, Central's holdings had not been made "live" in the catalog, so only the smart barcodes were listed in the holdings—one reference copy and one circulating copy for every single book—even those in Rare Books! Needless to say, this caused some initial confusion for both staff and patrons. Eventually when the collection went live, all the dumb barcodes were supposed to appear in the holdings and all the unused smart barcodes (mostly circulating copies of reference only books) were supposed to disappear, but not surprisingly there were some glitches along the way. Certain groups of unused smart barcodes remained behind in the catalog; in Literature, this problem was mainly in the 809.2's, for some reason. And the system was confused by odd fiction call numbers like "Ed. b," and many of these barcodes "migrated" to other completely different books that had the same "Ed." call number, with the result that some records would show 15 or 20 supposed copies of books (half reference, half circulating), and it was impossible to tell which represented actual books. All this took well over a year to straighten out, and some of it

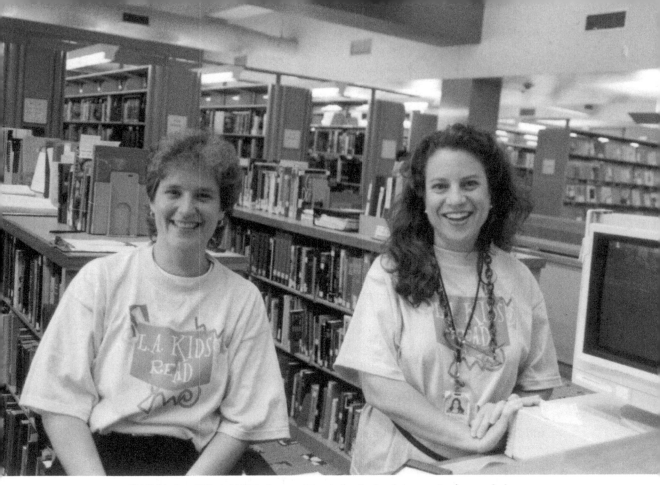

**Sheila Nash and Cindy McNaughton are pictured at the Art department reference desk
not long after the expanded Central Library reopened.
(Sheila Nash, Los Angeles Public Library Institutional Collection)**

was never completely fixed. Twenty-five years later, I still find "phantom" barcodes
in the 809.2's and our messenger clerks still discover closed-stacks books that never
got barcoded at all!

The telephone system was another big issue in the early days of "New Central."
In those pre-internet days we received many, many phone calls asking short-answer
trivia questions, or whether a book was on the shelf or in the collection. In most of
the larger subject departments, both pre-fire and on Spring Street, we had a phone
system with four reference lines, and it was very common to have all four of those
on hold while clerks were searching for books, or we were looking for the answer to
a reference question. It was quite a shock when we learned that our new telephone
system would just have one reference line at each workstation, and that library ad-
ministration had signed off on this. The phone company people were surprised
when we raised this objection; they had assumed (because no one told them dif-
ferently) that we would deal with one call at a time, finish that one, and go on to the
next one. They came up with a solution of sorts; if we had someone on hold waiting
for an answer, we could transfer that call to another line so our main line would

open up for another call. This proved to be extremely cumbersome, and most of us settled for answering one call at a time and letting other callers wait. The initial plan for the reopened building had been to have a large walk-in reference and telephone area on the first floor where the Popular Library is now located. It was supposed to have a dedicated staff, but since there had been staff cuts rather than additions, that did not happen, and the subject departments wound up staffing that desk in the early days. The subject departments' direct phone numbers were also widely publicized in those days and appeared in telephone books, so a smaller percentage of calls went to the centralized number. It would be several years before staff levels rose to the point that InfoNow was created to handle a large portion of telephone calls.

Another big issue in the first years back at Central Library was Sunday hours. In 1993, no LAPL agency had been open on Sundays for many, many years. As part of Central's opening celebration, it was announced that the building would be open on Sunday afternoons for the first month, using volunteer staff from throughout the system who wanted to work overtime. Sundays proved extremely popular with the public, and what began as a temporary arrangement was turned into a permanent one. Since overtime had only been approved for those few weeks, the Sunday situation became increasingly complex and required protracted negotiations between library unions and administration. While the negotiating was going on, Sundays remained voluntary, but those who worked them would get hours off other days of the week rather than overtime. As a result, the number of volunteers gradually diminished. It was not unusual for entire subject departments to be staffed on Sundays with employees from other departments and agencies, which caused problems as well. It took quite a few years before the current Sunday hours procedures were agreed on and Sunday became a regular part of the work week for Central and regional branch staffs.

One feature of the restored Central Library that no longer exists is the Translogic system. Translogic was built into the new Bradley wing while it was under construction. It consisted of an electronic rail system with lidded carts to transfer books and other materials from one part of the building to another. It somewhat resembled a miniature roller coaster, with its steep ascents and descents; I understand that it even traveled upside down in some of the segments hidden away from the public eye. There were, I believe, 17 stations, located at each reference desk and each closed stacks area. You would place some books in a cart, snap the lid closed, turn the dial to the number of the station where you wanted to send the books, then press a button. With a couple of beeps, the cart would shoot off, and another empty one would appear in its place. It took a number of months after the grand opening before Translogic was operational; it had to pass a number of fire department inspections. Like the rest of the building, it had its own fire doors. While Translogic was still in the planning stage, there was talk of using it to save patrons from having

to go from floor to floor. If they came to a particular department and some items they wanted were on other floors, the staff would call the other departments and have the books sent via Translogic. By the time we actually opened, it was clear that this much use would overtax the system, and we mainly used it to request periodicals and microfilm, though sometimes we would send books from other floors back to their correct departments. But all those heavy periodical volumes took their own toll on the system, and it was frequently out of order. The amount we could send in one cart was gradually lowered until we were only allowed to send one large or medium-sized volume at a time, despite the carts' size suggesting that they could hold much more. The cost of the constant repairs and the system's inefficiency eventually led to its discontinuation, but it was a rather charming addition to Central Library while it lasted, even if it never worked as advertised.

About 100 days after our opening day, the Northridge earthquake hit Los Angeles. It occurred at 4:30 in the morning and happened to be on the Martin Luther King holiday, so Central Library staff had a little time to get our own lives in order before returning to work. The building did not have any major damage and could reopen fairly quickly, though of course much of the collection wound up on the floor, particularly on the upper levels. The basement floors moved along with the earth and had relatively few books to reshelve. The worst job was dealing with the compact shelving, which had to be opened aisle by aisle; as each pair of shelves separated, dozens of books would fall to the floor. While Central Library's recovery was quick, many branch

buildings, particularly in the San Fernando Valley, sustained such severe damage that they were closed for extended periods. As a result, we experienced a reversal of what had happened during the years after the fire. This time it was Central staff's turn to host many of our branch colleagues, just as they had made us feel welcome in the aftermath of that earlier disaster.

View of the Translogic track during construction.
(Renny Day & Bob Day, Los Angeles Public Library Institutional Collection)

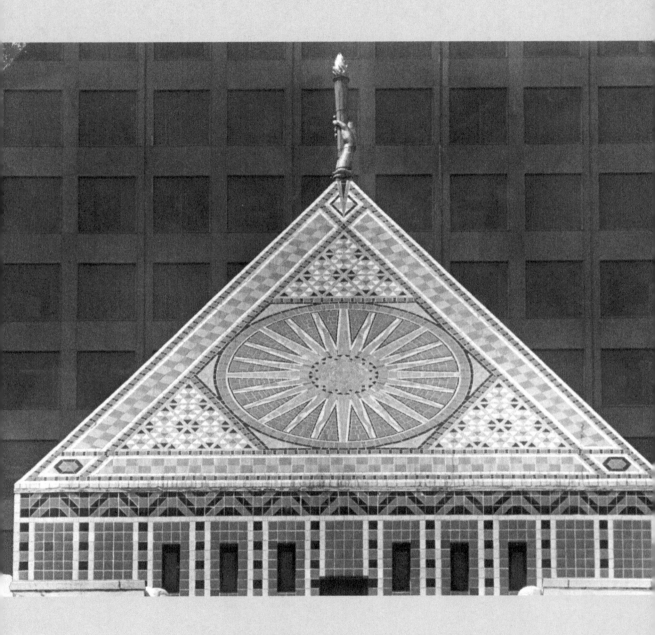

The Light of Learning perched atop the Central Library pyramid, set against one of the ARCO towers.
(Ken Papaleo, Los Angeles Herald Examiner Collection)

EPILOGUE

By MARGARET BACH
founding president, Los Angeles Conservancy

THE PRESERVATION OF the Central Library—and the fight to save it—marked a watershed moment for historic preservation in the Los Angeles region.

The existential threat to what may be our most iconic civic landmark—and one of architect Bertram Goodhue's most important buildings—served as a catalyst for a movement, inspiring a small group of activists to create something new for Los Angeles: an organized voice for historic preservation. In 1978, as the fight to save the Central Library was ramping up, the Los Angeles Conservancy was born, and it has grown in its 40 years to become the largest local historic preservation organization in the nation.

Yet an account of the Central Library's preservation would not be complete without acknowledging something perhaps even more significant. The effort to save the building, and to revitalize it to meet future needs, ultimately produced a rare consensus among stakeholders in Los Angeles.

Early advocates, along with the Conservancy, were the American Institute of Architects—from their chapter offices in the historic Bradbury Building—with their important 1978 study and their legal challenge to an inadequate EIR. The downtown business community—notably ARCO, Maguire-Thomas, and the Central City Association and others—also stepped forward with support and influence. The Community Redevelopment Agency played an essential, pivotal role, offering financial strategies and tools that made the renovation and expansion of the landmark building possible.

These collective efforts culminated in a plan, ultimately adopted by the city, to preserve, renovate and expand the Central Library to house a vibrant array of services and cultural offerings.

Preservation, and the civic values it represents, had thus joined the conversa-

tion about the future of Los Angeles. In ensuing years, the Central Library continued to serve as a touchstone for advocacy that spread to embrace not only the iconic, signature buildings of the region but also neighborhoods, vernacular buildings and culturally significant places.

Examples of progress are many. The City of Los Angeles bolstered its support for preservation, with the creation of the Office of Historic Resources and Survey LA, funded by The Getty, the first comprehensive program to identify the city's historic resources. Thirty-five Los Angeles neighborhoods, and counting, are now protected as Historic Preservation Overlay Zones. Other L.A.-area municipalities have launched their own preservation programs. And thanks to the city's Adaptive Reuse Ordinance, along with robust market forces, the revitalization of downtown L.A.'s historic buildings for housing, arts and commerce has reached a new high. The list goes on.

Yet despite these significant gains, preservation today operates in a more challenging environment. In the face of the complex urban issues facing our region —notably housing, affordability, density and gentrification—preservationists are obliged, as never before, to engage in these larger, contextual issues while continuing to advocate for the protection of the historic resources that give richness and meaning to the city in which we live.

And on this note, the question of meaning—we return to the subject at hand.

Meaning is what the Central Library—the building we fought so hard to save—is all about. Its noble public purpose, its unifying theme of "Light and Learning," its embrace—through its architecture and decoration—of diversity, inclusiveness, and the great civilizations of the West and the East, all combine to offer an exemplary lesson for our time. May this glorious, complex building continue to serve as a model, and inspiration, for our urban future.

**Opposite and page 136: Views of the architect's model for Central Library.
(Los Angeles Public Library Institutional Collection)**

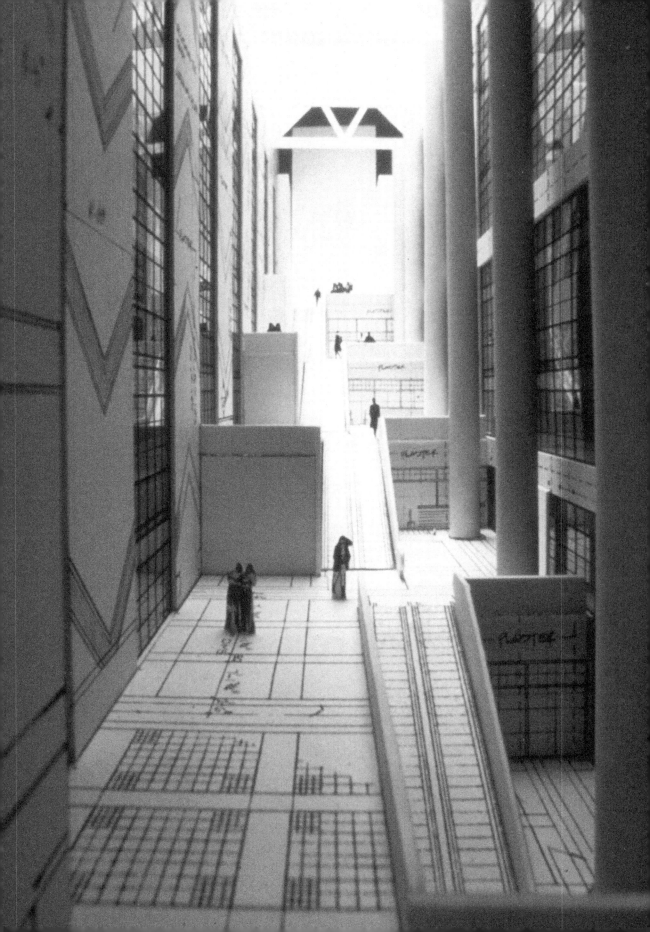

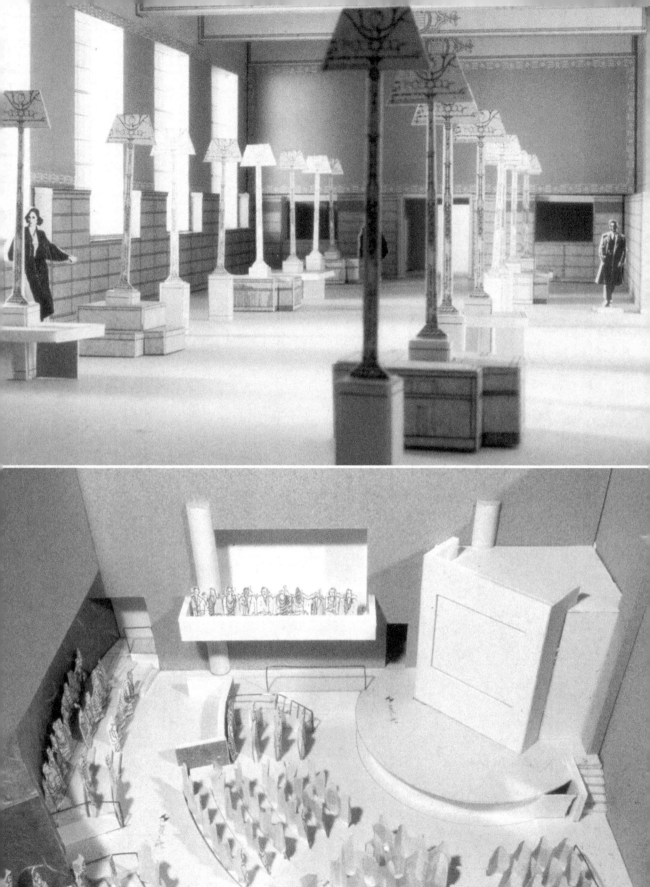

BIBLIOGRAPHY
for "A Wanderer and Homeless Waif"

"Althea Warren to retire Wednesday as Librarian." *Los Angeles Times* (September 28, 1947) A 1.

Apostol, Jane. Mary Emily Foy: "Miss Los Angeles herself." [Los Angeles?] Historical Society of Southern California [1997?]

"At the City Hall; waxing warm." *Los Angeles Times* (January 17, 1896) 9.

"Building wrecker." *Los Angeles Times* (July 9, 1905) VI 9.

"Business blocks." *Los Angeles Times* (January 1, 1898) 69.

"Central Park for the Library." *Los Angeles Times* (October 13, 1906) II 4.

"Child's theater at Hamburger's." *Los Angeles Times* (October 4, 1907) II 6.

"City and environs." *Los Angeles Times* (June 1, 1914) I 8.

"City library's move started." *Los Angeles Times* (June 20, 1926) C 1.

"City's oldest library celebrates." Southwest Wave (March 16, 1983).

"Correspondent writes ... " *Los Angeles Times* (August 21, 1889) 4.

"Dark mystery yellow flake." *Los Angeles Times* (December 30, 1906) II 6.

"Downey's new block." Los Angeles Daily News (September 27, 1871) 3.

"Dr. Lummis walked across country for job on 'Times.'" *Los Angeles Times* (November 26, 1928) A 2.

"First woman librarian feted on 96th birthday." *Los Angeles Times* (June 13, 1959)

"For a center of recreation." *Los Angeles Times* (February 13, 1922) II 5.

Foy, Mary Emily. [Biographical data for Western History-Material] Los Angeles: Los Angeles Public Library, 1905.

[Foy clippings from Los Angeles Public Library, History Dept. California Index files on Mary E. Foy. Various sources, dates]

"Free library." *Los Angeles Times* (January 1, 1885) 3.

Frisch, Norman. "Mary E. Foy still keeps busy in the city she saw grow up." *Daily News* (July 8, 1952)

"Great store's first drill." *Los Angeles Times* (July 26, 1908) V 13.

Guinn, J.M. "True history of Central Park," Historical Society of Southern California Annual publications (1911) pp. 211-216.

"Hamburgers to build theater." *Los Angeles Times* (February 22, 1907) II 4.

"Historical notes." Friendly views newsletter [Los Angeles Library Association] 1 (November 1979) [3, 5]

Hjelte, George. Footprints in the parks. Los Angeles: Public Service Publications, 1977.

Hyers, Faith Holmes, comp. "Brief history of the Los Angeles Public Library." Part two of Los Angeles Public Library's Annual report of the Board of Library Commissioners of the Los Angeles Public Library. Los Angeles, Calif.: 1927.

"Interesting Library facts." *Los Angeles Times* (December 13, 1899) 10.

Lewis, William S. John Gateley Downey; an early go-getter. [unpublished MS in California Biography File, Los Angeles Public Library, History Department]

"Library Board called names." *Los Angeles Times* (October 6, 1922) II 2.
 "Library directors; preparations of opening the new quarters next Monday."

Los Angeles Times (August 15, 1889) 2.

"Library directors; satisfactory progress all along the line-monthly reports." *Los Angeles Times* (November 7, 1889) 2.

"Library faces greater duty." *Los Angeles Times* (April 29, 1906) II 1.

"Library gets new quarters." *Los Angeles Times* (April 10, 1913) II 9.

"Library is divided." *Los Angeles Times* (March 30, 1906) I 16.

"Library needs grow." *Los Angeles Times* (July 14, 1906) II 4.

"Library opens new quarters." *Los Angeles Times* (July 7, 1926) A 1.

"Library plans get set-back." *Los Angeles Times* (March 22, 1922) II 1.

"Library rental bids." *Los Angeles Times* (January 11, 1906) I 5.

"Library roof gardens." *Los Angeles Times* (August 4, 1906) II 4.

"Library wants to clear Hill." *Los Angeles Times* (April 18, 1922) II 3.

"Lights that failed; public library suffers from erratic illumination." *Los Angeles Times* (October 9, 1896) 9.

Los Angeles (Calif.). Board of Library Commissioners. The Central Library of
 Los Angeles; a report on the present building ... [Los Angeles]:
 Los Angeles Public Library, 1966.

"Los Angeles Public Library." *Los Angeles Times* (December 5, 1897) I 4.

Los Angeles Public Library. Annual report / Los Angeles Public Library.

[Los Angeles, Calif.: s.n.] 1889, 1890, 1905/1906, 1906/1907, 1907/1908,
 1909/1910, 1910/1911, 1911/1912, 1912/1913, 1913/1914, 1918/1919

Los Angeles Public Library. Hand book of the Central Building Los Angeles Public
 Library.

[Los Angeles] The Los Angeles Public Library [Printed by Dunn Bros.] 1927.

Los Angeles Public Library. Los Angeles public library, 1872-1920; how the
 library was established-how it has grown-what it is doing today for Greater
 Los Angeles why it should have a central building. [Los Angeles: The Library,
 1920]

"Los Angeles Public Library, 1872-1920; the years of development."
 Los Angeles Public Library monthly bulletin (14 February 1920) 98-103.

"Many visit library." *Los Angeles Times* (May 21, 1906) I 7.

"Mary Foy, City's first woman librarian, dies." *Los Angeles Times* (February 19, 1962)
 pp?

"Miss Mary Foy still busy on 9?th birthday." *Los Angeles Times* (July 14, 1956).
 "More funds needed." *Los Angeles Times* (July 22, 1897) 5.

Murphy, William S. "Then ... and now." *Los Angeles Times* (January 14, 1973) L 18.

"New library quarters." Library books; monthly bulletin of the Los Angeles
 Public Library. 9 #5 and 6 (May and June 1914) 67-80.

"New to-day." *Los Angeles Times* (November 10, 1882) 4.

Newmark, Harris. *Sixty years in Southern California. 1853-1913.* 3rd ed.
 Boston: Houghton Mifflin Company, 1930.

"Not ready to move." *Los Angeles Times* (February 17, 1906) II 6.

"Objects to coughing." *Los Angeles Times* (April 8, 1899) 9.

"100 years of good reading." *Los Angeles Times* (September 20, 1972) B 6.

"Pledge of librarians fulfilled." *Los Angeles Times* (January 6, 1923) I 4.

"Public library; an appeal from the Board of Directors." *Los Angeles Times* (April 7, 1889) 2.

"Public library; annual report of the Trustees." *Los Angeles Times* (December 14, 1893) 6.

"Public library; first meeting of the directors in the new City Hall." *Los Angeles Times* (August 22, 1889) 2.

"Public library; notes of its working under the new regime." *Los Angeles Times* (September 22, 1889) 3.

"Public library; opening postponed until September 1st," *Los Angeles Times* (August 17, 1889) 2.

"Public library; reopening today under the new management." *Los Angeles Times* (September 2, 1889) 4.

"Public library; report of the Board of Directors." *Los Angeles Times* (December 11, 1889) 2.

"Public library will move to great Hamburger building." *Los Angeles Times* (February 9, 1908) V 1.

"Publishers' announcements." *Los Angeles Times* (October 26, 1889) 4.

Rasmussen, Cecilia. "Librarian became an institution." *Los Angeles Times* (September 12, 1999) B 3.

"Reading public." *Los Angeles Times* (December 25, 1896) 5.

"Seeking to stop work on library." *Los Angeles Times* (September 22, 1922) II 6.

Soter, Bernadette Dominique. "The light of learning: an illustrated history of the Los Angeles Public Library." Los Angeles: Library Foundation of Los Angeles, 1993.

"Spring opening." *Los Angeles Times* (March 13, 1906) II 4.

"Stearns, Abel." City officials [Los Angeles]: Municipal Reference Library [n.d.]

Wheeler, Joseph L. "Every book right out upon an open shelf." *Los Angeles Times* (June 22, 1913) II 7.

ENDNOTES
for "From Belle to Burden and Back Again"

1 From about two million to just under four million, according to the Green
 Report. (*Los Angeles Public Library Central Library of Los Angeles Report on the
 Present Building with Recommendations for a Facility to Meet Service Requirements*)
 p 11

2 Green Report, p 4

3 Green Report, p 18

4 Green Report, p 30

5 Green Report, p 22

6 "City Library System at the Crossroads," John D. Weaver, *Los Angeles Times Book
 Review,* June 15, 1975

7 "Commissioner Favors High-Rise Library," Burt Wuttken *Los Angeles Times,*
 Aug 20, 1967; WS1

8 Weaver, *LA Times Book Review,* June 15, 1975

9 "The Book Stall: LA's Overdue Building," John Pastier, *New West,*
 August 1, 1977, SC-27

10 Pastier, SC-27

11 One can't be too hard on Luckman because library administration and
 commissioners were essentially saying the same thing as they were wedded to
 the idea of a massive new building.

12 Lorenzen was the recipient of the the largest amount of political
 contributions by Luckman Associates. (Pastier, SC -28)

13 "LA Library Renovation Doubtful," Scott Zonder, *Los Angeles Herald Examiner,*
 June 20, 1978, A-3

14 Pastier, SC-27

15 Pastier, SC - 28

16 Letters to the Times, *Los Angeles Times,* June 29, 1975

17 *Los Angeles Central Library: A History of Its Art and Architecture,*
 Arnold Schwartzman and Stephen Gee (2016), p. 186

18 "Library Dispute: Form vs Function," Joseph Giovannini, *Los Angeles Herald
 Examiner*, April 6, 1981. B1

19 In an interesting foreshadowing, Giovannani also noted that the library was
 under citation for fire code violations for which the DPS required a correction
 plan by the end of the month, and "by default the RFP seems to be the only
 promise of keeping the library open... even though there is, according to
 the fire department, no panic situation" and quoted Public Safety Second of
 the LAFD Ronnie Wreesman that in fact the library "presents no great fire
 hazard," a "2 or a 3 on a scale of 1 to 10," "Library Dispute." B5

20 "Important Issues" Los Angeles Conservancy Website.
https://www.laconservancy.org/issues/los-angeles-central-library

21 Schwartzman/Gee, p 184

22 "Welborne's great-uncle, Spring Street bond salesman James R. Martin,
bought the site of what is now the downtown library with a group of
businessmen who later sold it to the city for a dollar more than the group paid
for it." "Angels Flight Crash Mars Preservationist's Vision,"
Anne-Marie O'Connor, *Los Angeles Times*, February 04, 2001

23 "Important Issues" Los Angeles Conservancy Website.
https://www.laconservancy.org/issues/los-angeles-central-library

24 "Politics Also Undergird Skyscraper," Jesus Sanchez, *Los Angeles Times*,
April 17, 1989, A1

25 "A Prime Mover in a Prime Place," Leon Whiteson, *Los Angeles Herald Examiner*,
December 23, 1984, E12

26 Whiteson, E13

27 Sanchez

28 Schwartzman/Gee, p. 190

CONTRIBUTOR BIOS

ROBERT ANDERSON became a librarian in what was then the Fiction Department of Los Angeles Public Library in 1980. In 1991 he was selected as Fiction Subject Specialist for the Literature and Fiction Department and has held that position since then. He was, rather ironically, working on a weeding project in the Central Library closed stacks on the day of the 1986 fire, and he considers the subsequent seven years that ended in the Grand Reopening to be the most traumatic but also the most transforming and inspiring of his life and career.

MARGARET BACH has a longstanding engagement with the built environment, as a designer, writer, documentary filmmaker, historian and preservation advocate. Highlights include: founding president of the Los Angeles Conservancy; project coordinator/editor for the AIA's 1978 study, *Guidelines for Preservation, Restoration and Alterations to the Central Library of Los Angeles*; editor of *L.A. Architect*; manager of KCET's award-winning public television series, *L.A. History Project*; restoration of Irving Gill's Horatio West Court in Santa Monica. She has written extensively about the Los Angeles built environment, and now devotes her time to her interior design and art practice, her family and grandchildren, local history and community work.

GLEN CREASON has been the map librarian for the Los Angeles Public Library for the past twenty-nine years and a reference librarian in the History department since 1979. He was a co-curator of the landmark map exhibit *Los Angeles Unfolded* in 2009 and in October of 2010 he published the book *Los Angeles in Maps* for Rizzolli International. He has written about local history, maps and popular culture for local publications including the *Downtown News*, *Mercators World*, the *International Map Collectors Society Journal*, the *Public Historian*, the *Communicator*, the *Los Angeles Times* and *Edible Ojai*. He blogged weekly on maps for 170 posts as a columnist for *Los Angeles Magazine* and is a contributor on research topics for the Huffington Post and LAist.

In the History & Genealogy Department at Central Library, **GLENNA DUNNING** (1947-2015) was the go-to librarian with questions relating to really early Los Angeles history and was able to keep all those adobes and ranchos straight. If some aspect of Los Angeles history piqued her interest, it wasn't long before an article she penned on the subject showed up in the Los Angeles City Historical Society newsletter. Glenna's many historical writings are cited in the library's California Index, and serve as a tangible reminder of the dedicated librarian who served her beloved city well. A fully cited version of "A Wanderer & Homeless Waif" is available in the Central Library Literature & Fiction Department, at the Reference Desk.

DELORES MCKINNEY dug up her Oklahoma "roots" and replanted them in Los Angeles in 1964...with great success! She loves Los Angeles...its rich history, its vast stretches from Pacific beaches to the mountains, its generous welcome to the world to come and make your place, just as she did. What a city!! After 38 years as (she says modestly) an excellent server at the National/Sepulveda Hamburger Hamlet, she began her "second career" as a receptionist when the Hamlets closed. A Library docent since 1991, she also volunteers for L.A.'s Metropolitan Transit Authority, taking tours to learn and enjoy the public art at the rail stations.But her heart belongs to Central Library!

SHERYN MORRIS, Reference Librarian II, works at LAPL's Central Library, Literature & Fiction Department, and is the editor/contributor for LAPL Reads. Past work: Children's librarian, Beverly Hills Public Library and LAPL; adult reference librarian at Palos Verdes Library District, Redondo Beach Public Library, Long Beach Community College; catalog reconversion project at UCLA; management of law firm libraries; and substituted for numerous public library systems in Los Angeles County. As a Children's librarian, she was a storyteller; as a reference librarian she regularly was invited to present book reviews for adults at public and private institutions.

CHRISTINA RICE started with the Los Angeles Public Library in 2005 as a Reference Librarian at the John Muir Branch and the History & Genealogy Department at Central Library. Since 2009, she has been the Senior Librarian of the LAPL Photo Collection. She is the author of *Ann Dvorak: Hollywood's Forgotten Rebel* (2013, University Press of Kentucky), and the writer of multiple issues of the *My Little Pony* comic book series (IDW Publishing). She is currently working on a biography of actress Jane Russell.

JAMES SHERMAN is a librarian in the Literature & Fiction Department.

JOHN F. SZABO is the City Librarian of the Los Angeles Public Library, which serves over four million people—the largest population of any public library in the United States.

He has more than 25 years of leadership experience in public libraries, previously serving as the director of the Atlanta-Fulton Public Library System, Clearwater (FL) Public Library System, Palm Harbor (FL) Public Library and Robinson (IL) Public Library District. Throughout his career, Szabo has championed innovative library services that address critical community needs in areas including health disparities, workforce development, adult literacy, school readiness and emergent literacy for preschoolers.

He currently serves as Chair of the Board of Trustees of OCLC and on the

Board of Directors for California Humanities and the University of Southern California's Center for Library Leadership and Management. He has previously served on the Executive Board of the Urban Libraries Council and as president of the Florida Library Association.

BETTY GAY TEOMAN began her career at the Los Angeles Public Library in 1969 and held a variety of positions throughout the system before coming to Central Library in 1984. From 1983 until the October 3, 1993 opening of the rehabilitated and expanded Central Library, she also served as the Library's Liaison and Project Manager, working with Hardy Holzman Pfeiffer Architects and City and Community Redevelopment Agency staff to complete the building's planning, design, financing and construction. It was a creative, successful public-private partnership. Due to the 1986 arson fires which struck the building, this work included assisting with disaster recovery efforts. In 1998, she retired from the Los Angeles Public Library after a 30-year career, later lending her expertise to the Rye Free Reading Room in Rye, New York and the Rancho Mirage Public Library. Currently retired, she resides with her husband Kory in Rancho Mirage.

Betty is a native of Lexington, KY. She earned her BA in English from Vanderbilt University, MLS from the University of California, Berkeley, School of Librarianship, and MBA from UCLA's Anderson School of Management.

THANK YOU

Robert Anderson, Christine Adolph, Margaret Bach, Ani Boyadjian,
Brenda Breaux, Joyce Cooper, Glen Creason, Sarah Curup, Renny Day,
Glenna Dunning, Terri Garst, Sye Gutierrez, Wendy Horowitz, Amy Inouye,
David Kelly, Michael Kirley, Terri Markson, Delores McKinney, Sheila Nash,
Judy Ostrander, Peter Persic, Fernando Saucedo, John F. Szabo,
Betty Gay Teoman, Kurt Thum.

**Opposite, below and following pages: The crowds were large and spirits high when the doors
of Central Library were reopened on October 3, 1993. (Photos courtesy of Gary Leonard)**

FEELS LIKE HOME

About the Photo Collection

The Los Angeles Public Library (LAPL) began collecting photographs sometime before World War II and had a collection of about 13,000 images by the late 1950s. In 1981, when Los Angeles celebrated its 200th birthday, Security Pacific National Bank gave its noted collection of historical photographs to the people of Los Angeles to be archived at the Central Library. Since then, LAPL has been fortunate to receive other major collections, making the library a resource worldwide for visual images.

Notable collections include the "photo morgues" of the *Los Angeles Herald Examiner* and *Valley Times* newspapers, the Kelly–Holiday mid-century collection of aerial photographs, the Works Progress Administration/Federal Writers Project collection, the Luther Ingersoll Portrait Collection, and the landmark Shades of L.A., an archive of images representing the contemporary and historic diversity of families in Los Angeles. Images were chosen from family albums and copied in a project sponsored by Photo Friends.

The Los Angeles Public Library Photo Collection also includes the works of individual photographers, including Ansel Adams, Herman Schultheis, William Reagh, Ralph Morris, Lucille Stewart, Gary Leonard, Stone Ishimaru, Carol Westwood, and Rolland Curtis.

Over 126,000 images from these collections have been digitized and are available to view through the LAPL website at https://tessa.lapl.org/.

About Photo Friends

Formed in 1990, Photo Friends is a nonprofit organization that supports the Los Angeles Public Library's Photograph Collection and History & Genealogy Department. Our goal is to improve access to the collections and promote them through programs, projects, exhibits, and books such as this one.

We are an enthusiastic group of photographers, writers, historians, business people, politicians, academics, and many others, all bonded by our passion for photography, history, and Los Angeles.

Since 1994, Photo Friends has presented a regular series called *The Photographer's Eye*, which spotlights local photographers and their work. In 2011, Photo Friends inaugurated *L.A. in Focus*, a lecture series that features images drawn primarily from the Photo Collection. We have presented programs on L.A. crime, the San Fernando Valley, Kelly–Holiday aerial photographs, and L.A.'s themed environments, among others.

With initial funding from the Ralph M. Parsons Foundation, Photo Friends sponsored the L.A. Neighborhoods Project by commissioning photographers to create a visual record of the neighborhoods of Los Angeles during the early part of the 21st century (all now part of the collection). To ensure the library's collection will continue to reflect such an important part of Los Angeles' history, a generous grant enabled Photo Friends to hire five contemporary photographers to document present-day industrial L.A.; these images have become part of LAPL's permanent collection and are available to view through the library's photo database. Photo Friends also curates photography exhibits on display in the History Department.

Photo Friends is a membership organization. Please consider becoming a member and helping us in our work to preserve and promote L.A.'s rich photographic resource. All proceeds from the sale of this book go to support Photo Friends' programs.

photofriends.org

FRONT COVER: Close-up view of the Central Library pyramid tower with the *Light
of Learning* perched atop, taken around the time of the 1993 reopening.
(Foaad Farah, Los Angeles Public Library Institutional Collection)

BACK COVER: Top: View of Central Library around the time of the 1993 reopening.
(Foaad Farah, Los Angeles Public Library Institutional Collection)
Bottom: "Class" photo of Central Library staff taken in December 1986.
(Los Angeles Public Library Institutional Collection.